STROUD
THROUGH TIME

Howard Beard

AMBERLEY PUBLISHING

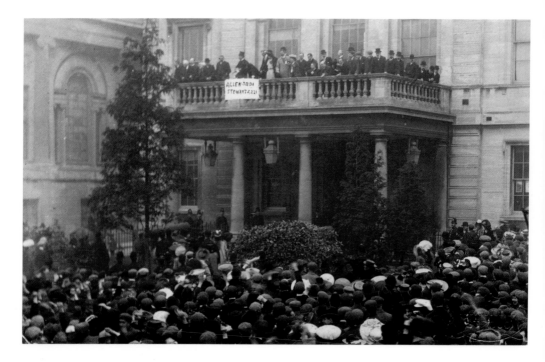

Election night in Stroud, 1906. Charles Allen was to continue to hold the seat for the Liberal Party until 1918.

To my wife Sylvia in grateful recognition of all her advice and assistance during the preparation of this book and its predecessors.

First published 2008
Reprinted 2010

Amberley Publishing
Cirencester Road, Chalford,
Stroud, Gloucestershire, GL6 8PE

www.amberley-books.com

British Library Cataloguing in Publication Data.
A catalogue record for this book is available from the British Library.

ISBN 978 1 84868 039 5

Typesetting and Origination by diagrafmedia
Printed in Great Britain

Introduction

Most people are fascinated by change. We value the opportunity to discover what our houses looked like a couple of generations ago, or how different grandma appeared on her wedding photograph. Similarly we are intrigued by changes in the local environment. The purpose of this book – indeed perhaps of the series – is to record these alterations by juxtaposing images from the past with contemporary pictures and to invite the reader to explore what has happened – often over a century – to the places with which we are familiar.

Almost a hundred old photographs in this book, nearly all from the author's collection, show how the passing of a similar number of years has changed Stroud.

Landscapes and more distant views show the effects of housing development and the loss of open spaces. Obviously some areas are now more wooded than was once the case, although often the opposite is true. In fact, sometimes the recent construction of buildings, or tree growth, makes it difficult for the modern photographer to take a picture from the exact spot where his Edwardian predecessor stood.

Street scenes are usually easier to re-photograph than rural locations. Within towns what catches the eye is the change of names over business premises, the loss of splendid Victorian façades, the absence of sun blinds and the disappearance of so many projecting trade signs. However, although shop windows of today may lack the sheer quantity of items formerly crammed into them, they certainly show an improved standard of display.

Street furniture is very different from that of a century ago: traffic signs have proliferated, alongside double yellow lines. Barrow traders are generally fewer. In Edwardian times there was a thriving group of these up on the Cross, the open triangle in Stroud where High Street meets Nelson Street and Parliament Street. One of these was a butcher. The author's father, born in 1901, used to recall how he was sometimes sent late on Saturday evenings to buy meat at the Cross

for the Beard family's Sunday lunch – at bargain prices because the trader had no refrigeration and knew that his produce would not keep until Monday. Sunday trading would, of course, have been out of the question in 1910!

Oddly, perhaps, telegraph poles are taller and far more obtrusive on early images than on their modern counterparts. The surface of streets is of rolled road-stone – very little tarmac a hundred years ago – with cobble-stoned gutters and the evidence of many a passing horse!

Edwardian streets also look very different from those of today because of the almost total absence of the motor car. Residents of modern Stroud will never have seen Lansdown or Horns Road completely empty of motor traffic. A century ago most of our ancestors would have cycled or walked to work. Leisure time would have meant dressing in best clothes for a walk on the Common near Rodborough Fort – a regular Sunday afternoon activity – perhaps with a picnic and a few simple toys for the children to enjoy.

A close comparison of old and modern pictures of private houses will reveal further changes. Dormer windows have come and gone. Gardens full of neat displays of flowers and vegetables may well have lost them to lawns, which are much easier to maintain, or to gravel or tarmac laid down in front of new garages. Extensions – granny flats perhaps – have often been added to buildings, while tennis courts at larger properties have been sold off for infill development. However, perhaps the most obvious change to the external appearance of private houses is the wholesale removal of ivy and Virginia creeper, which our forebears seem to have considered so attractive.

Churches have changed too. Many non-conformist buildings, no longer needed for worship, have been altered into private dwellings, or are now used for business or leisure purposes. Examples are the former Primitive Methodist Chapel in Parliament Street, now converted into Stroud's own Cotswold Playhouse and the Methodist Chapel in Castle Street which became flats following an agreement with the Anglicans to share premises at St Alban's. The Old Chapel Congregational building was demolished around 1970, when church leaders decided to concentrate on maintaining only one structure, the one in Bedford Street. Holy Trinity Church, still very much a part of the community, is of interest externally because of the loss of its turrets and internally on account of the painting over of its remarkable Victorian murals.

Changes in dress also provide an obvious area of interest. Bonnets, aprons and boaters have disappeared and boys are no longer sent to school in caps, jackets, ties, waistcoats and stout boots during even the hottest summers.

Today crowds do not assemble in front of the Subscription Rooms in their hundreds to wait for the declaration of poll on election nights; nor has there been a community drama production that has come close to matching in numbers the eleven hundred participants who took part in

the splendidly named Mid-Gloucestershire Pageant of Progress staged at Fromehall Park in the late summer of 1911. Children no longer pose for photographers seeking local colour to brighten up picture postcards – the novelty of this has long gone. Nor will we see again the grand decorative transformation which overtook Stroud when it celebrated King George V's Coronation, or the visits of the County Agricultural Show in 1907 and 1912.

Street advertisements still abound today, but many current ones would offend the religious and moral sensibilities of people a century ago. Also the graffiti and vandalism which mar so much of our current urban environment would be incomprehensible to Stroud's Edwardian residents.

In addition we may observe differences which point to changes in climate: for example the great frosts and heavy snowfalls of the winter of 1916 provided photographers with material we can hardly match today.

Although this book is by no means the author's first foray into print it does represent his maiden attempt to introduce his own colour photographs. The challenge has proved exciting, but beset with many problems. Firstly, pictures needed to be taken during what proved to be the cloudiest August in living memory. Many an expedition into the town had to be aborted on account of dull conditions or rain and on various occasions repeated visits to streets or to buildings were necessary before the sun was (if actually visible) in a favourable position in the sky. Another problem frequently encountered was the presence of the ubiquitous white van at all hours in pedestrian streets, or private cars parked in unauthorised places. A couple of early morning sorties even involved the removal of unsightly litter judged to spoil a potentially interesting picture – perhaps it would have been more honest had the author left it where it was...

In conclusion, readers are invited to study the contrasts apparent in the pictures on the following pages and to enjoy discovering how Stroud has changed over a century – whether for better or for worse will, of course, be up to the individual to decide.

Howard Beard

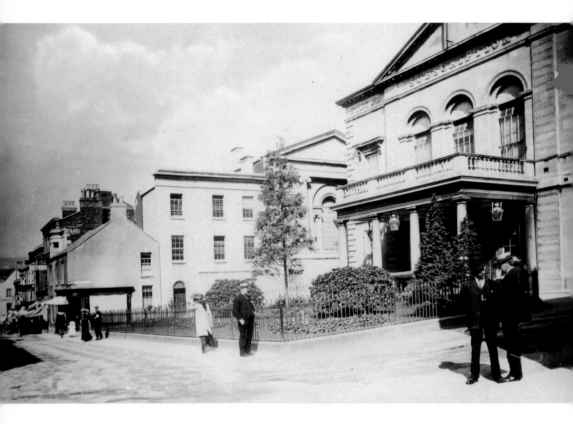

The Subscription Rooms Forecourt

A single hornbeam now replaces the railings, bushes, garden and Crimean War cannon in the sepia picture of around 1910. The building on the corner of Bedford Street, now an estate agent's premises, has been completely rebuilt and the Subscription Rooms portico has lost its large gas lamps.

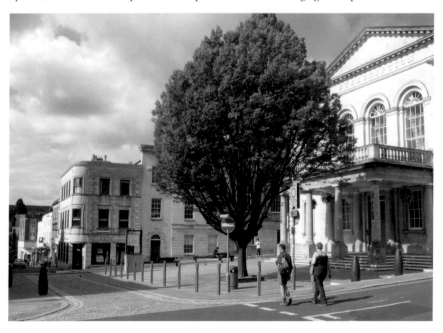

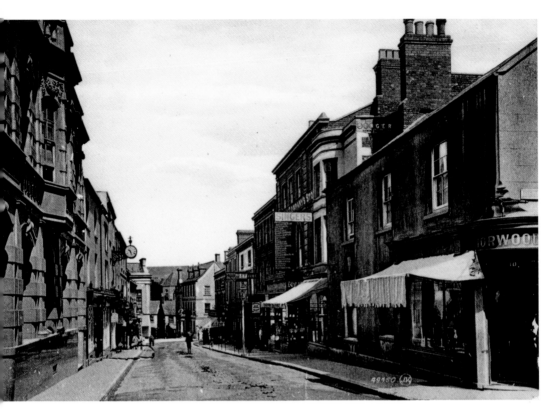

George Street, looking down

When this picture was taken a century ago the bank on the left, then the Wilts and Dorset, was only a few years old. The Royal George Hotel can be seen, sideways on, at the end of the street. Note the gas lamp on the right. Nearly all the buildings in George Street remain largely unchanged from first floor level upwards: it is, of course, the shop fronts that have altered.

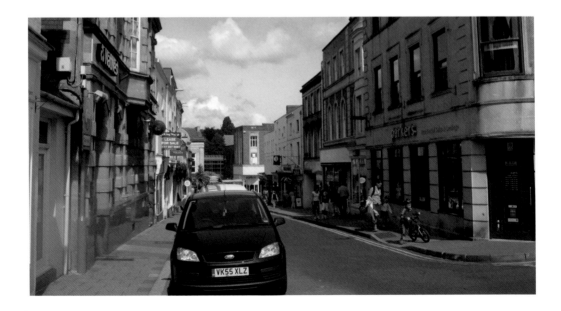

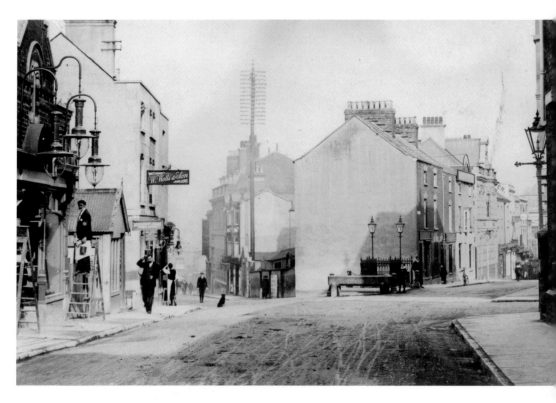

The junction of George Street, Russell Street and John Street circa 1910
The most obvious difference here is the absence, on the Edwardian picture, of Sims' clock, which was put up after the First World War. Note that the street does not have a tarmac surface. The two gas lamps by the horse trough marked the entrance to a gentlemen's underground toilet. Beyond the building on the left, with the splendid triple lamps, can be seen Merrett Brothers' photographic studio and Walter Wells' jeweller's business. The huge telegraph pole comes as something of a surprise to the modern eye.

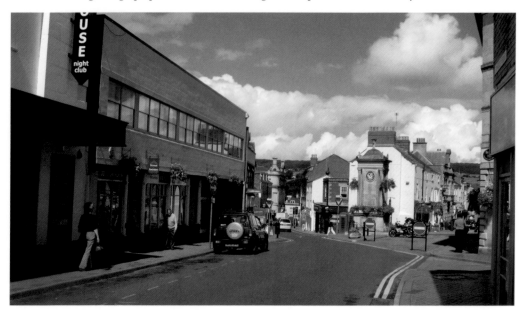

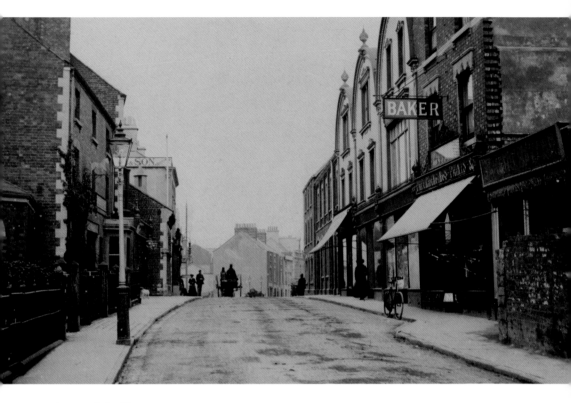

London Road, looking west
Apart from the distant buildings at the top of George Street, almost everything on this 1910 picture has gone. Most of the houses on the left, including the author's family blacksmith's business (see the horse sign on the wall just by the lamp post) were demolished around 50 years ago, as were some of those on the right. Baker's, originally a picture-framing concern, moved across the street to the site where we remember it selling paint and wallpaper. The kink in the right hand pavement has also been ironed out.

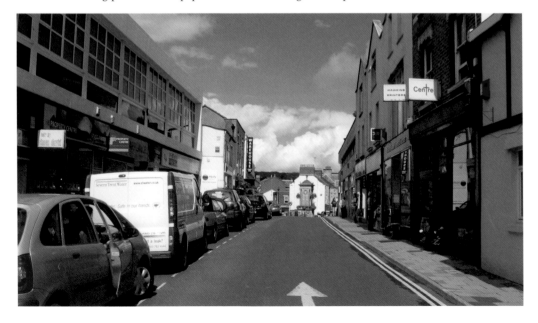

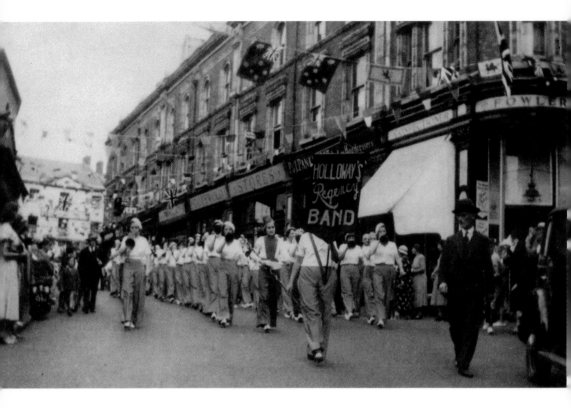

Kendrick Street

In this picture taken, it is believed, in the 1930s, Holloway's Regency Jazz Band is seen on parade. The shop terrace on the right is architecturally very fine and Walker's Bakery – then Fowler's – retains what many consider to be Stroud's best-preserved Victorian shop front. It has recently been beautifully repainted. The well-proportioned Georgian building at the end of the street was, for more than a century, Withey's grocery store. Out of view to the right, in Threadneedle Street, were the extensive clothing factory premises owned at one time by George Holloway, whose statue stands in Rowcroft.

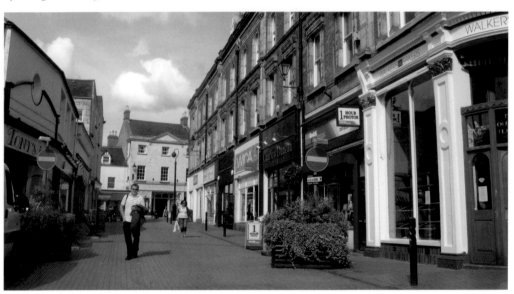

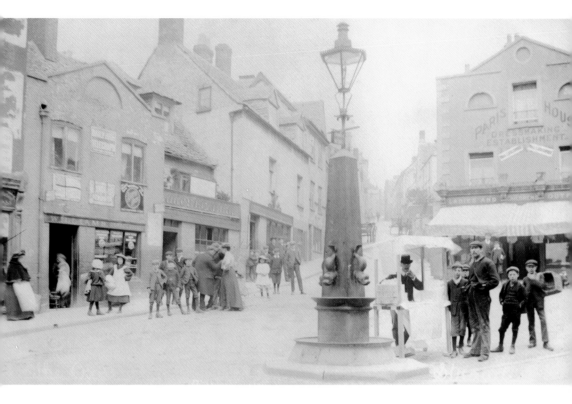

The Cross

What a transformation here! Apart from a few homes in the misty distance, everything on the 1910 photograph has been demolished. Paris House, the draper's on the right, was replaced in 1931 by the Stroud Co-operative Society's complex of shops. Demolition of buildings on the left was followed by the construction of the Police Station and Magistrates' Court. The pedestrianised High Street has, of course, now been blocked by a wall. Barrow traders had their pitches by the iron fountain (one dolphin survives in the Museum in the Park.)

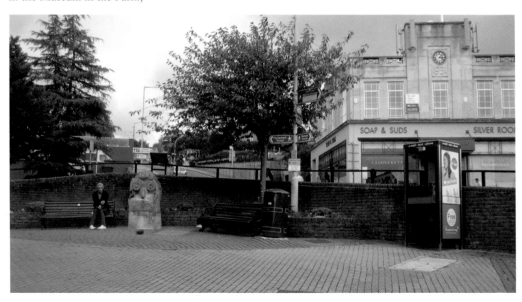

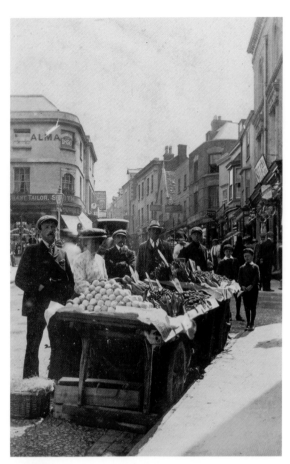

The junction of High Street with Kendrick Street

Until quite recently a flower seller had a stall roughly where his Edwardian predecessor sold fruit and vegetables. In the superb earlier picture note Alma House on the left, at this stage already established for half a century. The business was a gentlemen's outfitters and was formerly run by families called Birch and Monaghan.

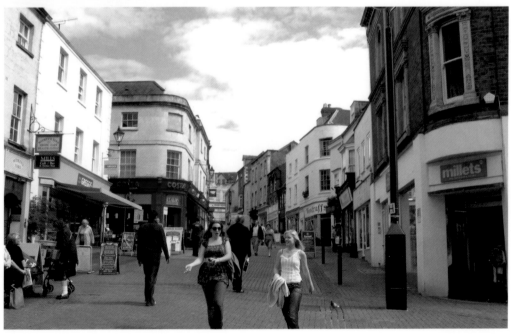

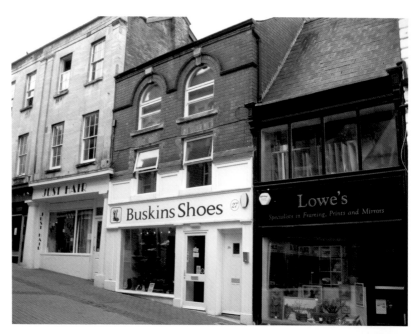

Number 27, High Street

The upper part of this building remains
unaltered. By contrast, at ground level we
observe a total transformation from Mr
Llewellyn's delightfully cluttered Edwardian
premises, to a modern, recently renovated shoe
shop. However, were it possible to obtain a
photograph of the establishment in the 1870s,
one might see a different picture again: at that
time number 27 was occupied by F T Lee, the
author's great-grandfather, who ran a tailor's
business there. He was the first of the Dorset
clan to come to Stroud from Bridport. The
more celebrated branch of the family later
moved to Slad.

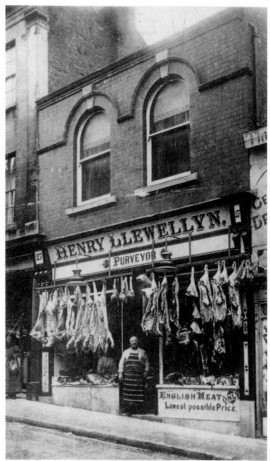

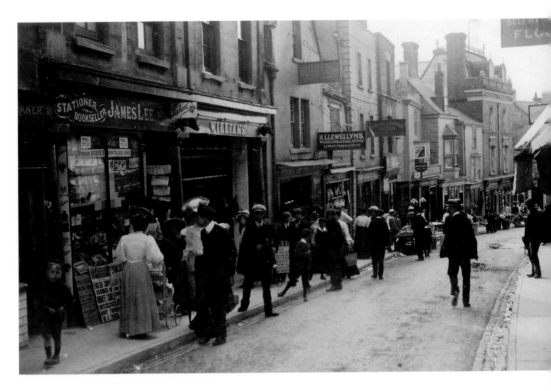

The Upper High Street

Two doors up from his brother's tailor's shop, James Lee opened a stationer's business in 1891. A dozen or so years later his son, William Frederick, started using his photographic skills to produce picture postcards – this is one – which were, of course, sold at James' shop. The proliferation of signs makes the street look both busier and perhaps more interesting than is the case today.

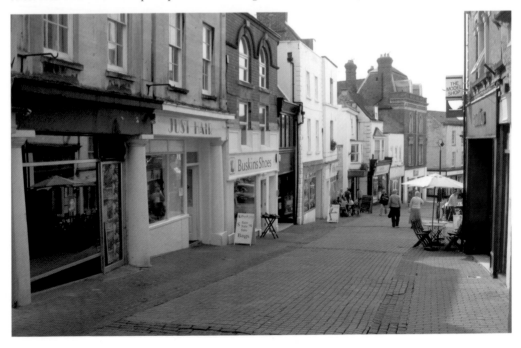

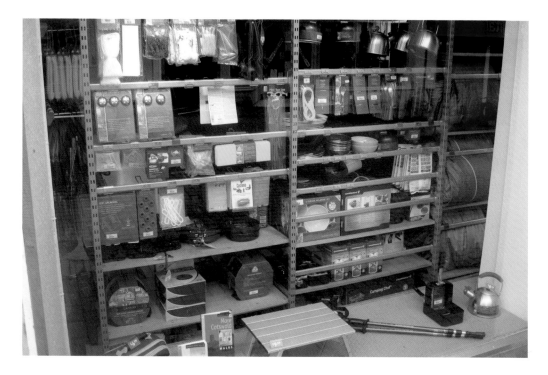

A Milliner's Window

Would present-day Millets, on the corner of High Street and Kendrick Street, recognise their shop window of nearly a century ago? The photograph below was taken around 1910 by Henry Comley, who ran his business from the same premises in Russell Street that Peckham's occupied until recently. The picture is so well-focused that, on the original postcard, price labels of 10/11 (55p) and 5/11 (30p) can clearly be read.

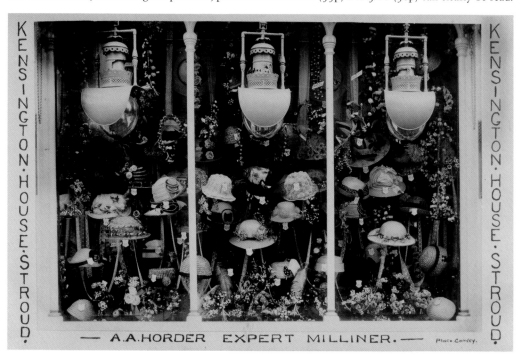

The Lower High Street, looking up

Once again see how cluttered the shop fronts looked in 1910 compared with today. It is also interesting to note how common it then was to hang goods outside the windows. In today's age of more questionable honesty would such a practice be possible – and would Mr Coward's magnificent lamps survive the activities of late night weekend revellers?

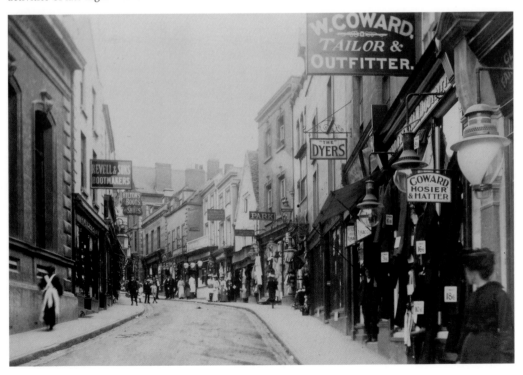

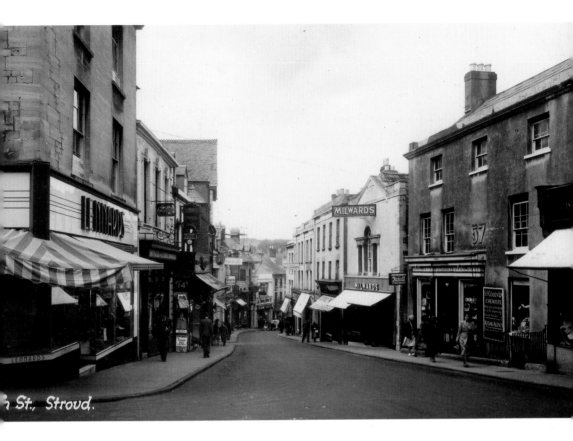

St. Stroud.

The Lower High Street, looking down

This picture, taken a generation or so after the previous one, shows us a street scene which many older residents will still remember: Lennard's shoe shop on the corner and, next to it, Smith and Lee – that pleasingly old-fashioned ironmonger's, where customer service and attention to detail remained priorities. Milward's, on the right, brings to mind the sustained and successful protest that occurred when demolition of this fine building, with its Venetian window, was threatened some years ago.

In the present day photo a band of South American street musicians is seen performing. Stroud has a distinctive set of street nameplates made from off-cuts of marble used in graveyard monuments. Note the one for Kendrick Street visible on the left.

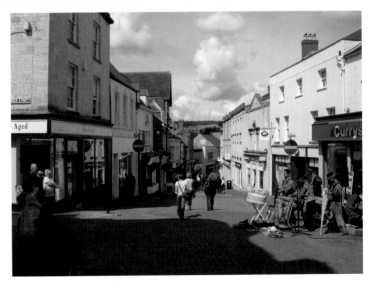

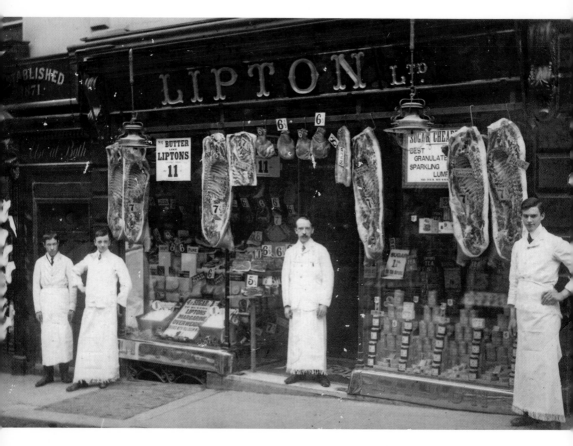

Lipton's Grocery Store, the High Street, circa 1911
Today's Health and Safety Inspectors would have a field day if faced with sides of bacon hanging outside in the open air!

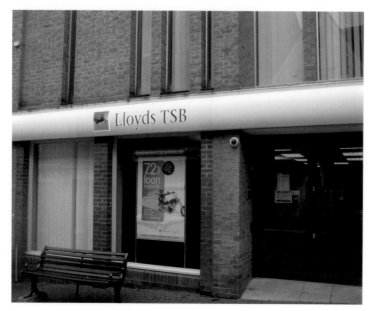

Present-day customers of Lloyds TSB might be surprised to learn that loose tea and sugar were once dispensed where they sat until recently to discuss bank loans.

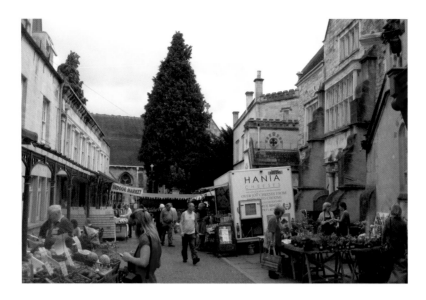

The Shambles

For the earlier image of this pair we have travelled back in time to 1861. The reason this engraving has been chosen is because it shows the old Parish Church prior to its demolition in 1866 and also the Town Hall before the construction of its supporting buttresses. Note that the familiar Shambles arcading on the left, and the churchyard gates and railings, were already in position when the engraver visited Stroud – observe also how artistic licence allows the exaggeration in width of this relatively narrow market area.

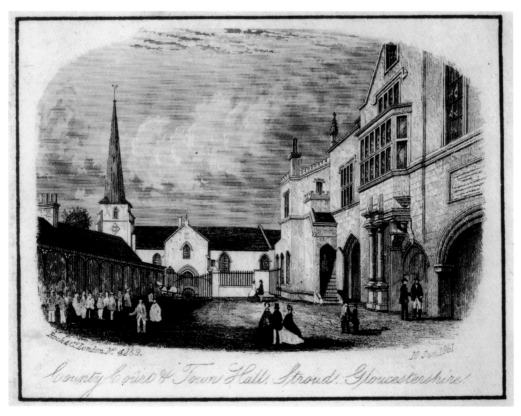

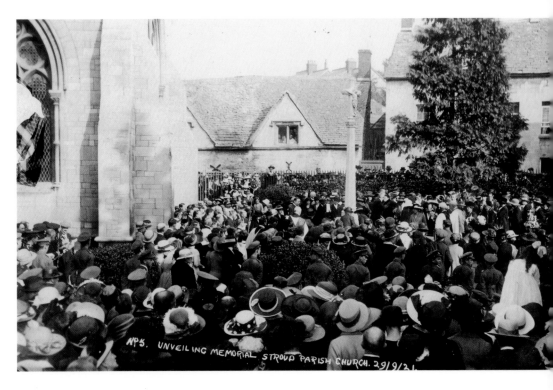

Dedication of the War Memorial

The precise dating of this interesting picture is made clear in the caption. Note the large number of people, many in military uniform, attending what must have been a highly poignant occasion for all present, since few families could have been unaffected by the Great War. The buildings in the background, from which further onlookers observed the ceremony, have gone and the car park and police station give the modern picture a very different appearance.

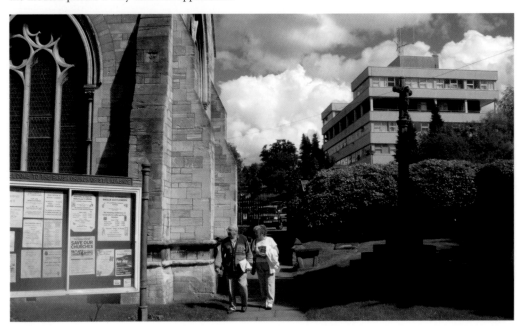

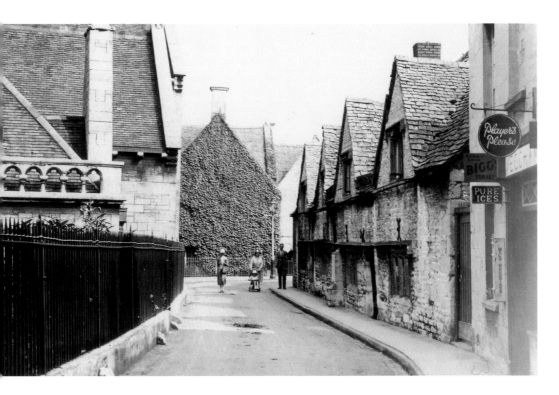

Church Street

In the 1930s Church Street still had its fine row of early almshouses. Just before the last war these fell into disrepair and a start was made to restore them. However, in 1939 the supply of necessary materials dried up, water penetration occurred and the condition of the buildings gradually worsened. By 1955 they are remembered as standing only up to window-sill level. Final demolition followed. In the writer's view this must be classed amongst the area's most serious architectural losses. Others include Stratford Abbey (of which more later), Ebley Court and the seventeenth century houses in Nelson Street.

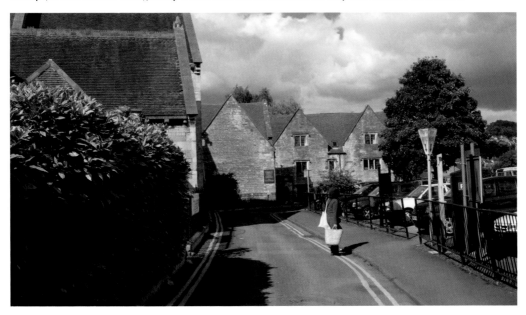

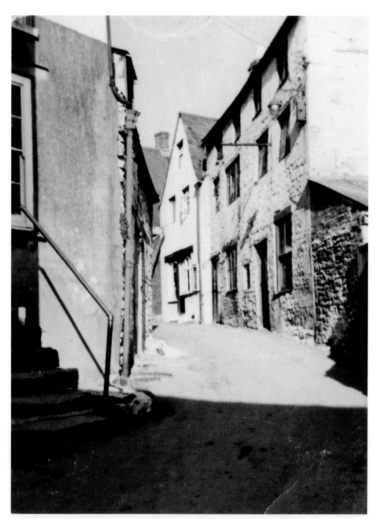

Swan Lane

The earlier of these two pictures dates back only about thirty years, but it would be unrecognisable to present day visitors to the town. Older residents will recall, in the terrace of cottages, Billy (W H) Knight's tinsmith's business, which later moved to Bath Street. Mr Knight was a great Stroud character, working on until well into his nineties. His firm is traceable back to around 1820. Along with the cottages the set of steps on the left has also gone. The edifice visible in the distance on the modern photo is the medieval building which was the subject of a restoration project in the 1980s.

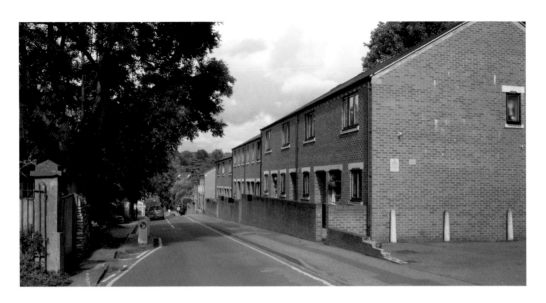

Brick Row

Holloway's clothing factory had only recently been built when the Edwardian view was taken by photographer Mark Merrett. It filled most of the upper side of Brick Row. Note how the door is located at just the right height for suits, jackets and trousers to be easily loaded onto waiting carts and wagons. Both the factory and the double-gabled building opposite have been demolished and, on the right, a residential development has replaced the earlier commercial premises.

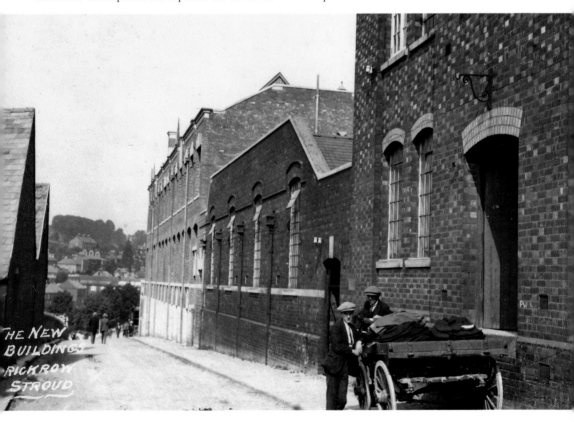

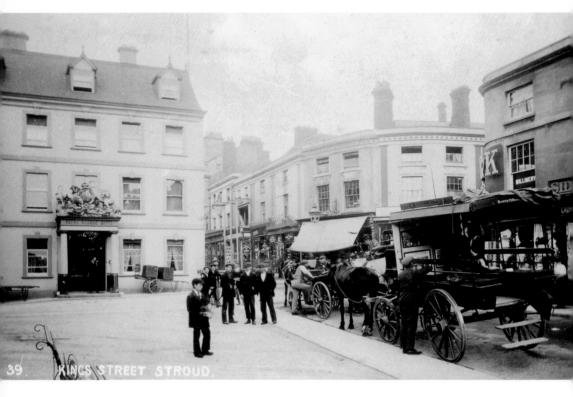

King Street Parade

The postcard from which this picture is taken was sent in 1909. A horse bus waits just where, today, modern taxis have their rank. The Royal George Hotel, with its beautifully carved coat-of-arms, was replaced in the 1930s by the art deco building older Stroud people still remember as Burton's the tailors. Sidney Park's drapery store on the right was also taken down at around the same time and the Midland Bank – now the HSBC – took its place.

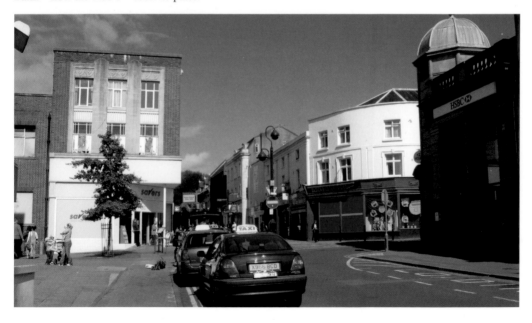

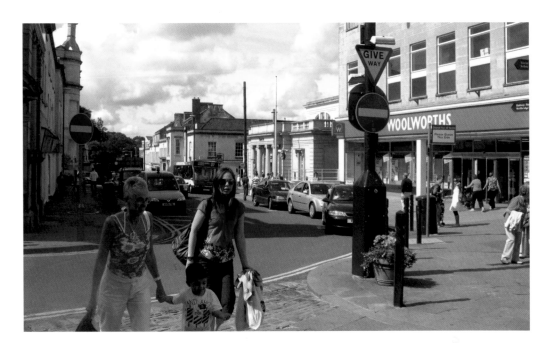

Woolworth's, King Street

King Street Parade was formerly one of Stroud's main open assembly points. The left two thirds of the nineteenth century building in the lower picture – the Victoria Rooms – were reconstructed when Woolworth's decided they needed more space. (One might be forgiven for venturing to say that the replacement is not an improvement.) The remaining third is largely unaltered and houses a shoe shop. Lloyd's Bank beyond has been completely rebuilt and the massive Stroud Brewery Company chimney – such a landmark in the town – has long gone. The earlier photograph dates from around 1910.

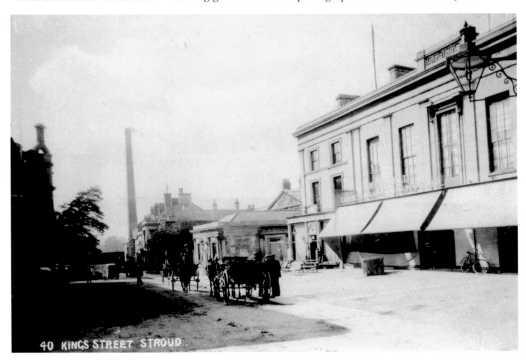

40 KINGS STREET STROUD.

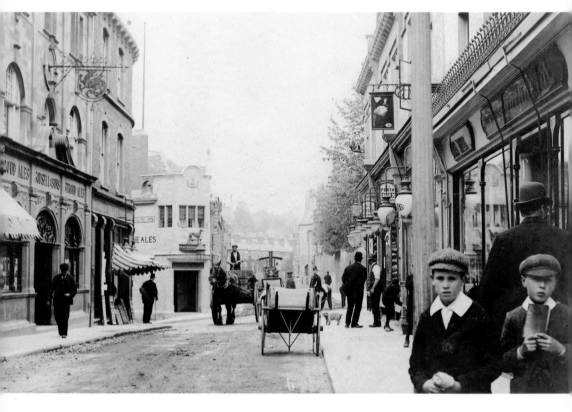

King Street, looking east, circa 1905
The upper floors of the Green Dragon pub on the left have been retained; until 2008 the much-altered ground floor housed Halford's which has now removed to Merrywalks. Previously it was the site of Stroud's first supermarket, which opened around 1955.

On both pictures WH Smith's, which established a branch in Stroud just over a century ago, has a projecting shop sign in roughly the same position. The parents of the boys on the right in the earlier picture would have been pleased that their sons featured on a picture postcard and would certainly have bought many copies.

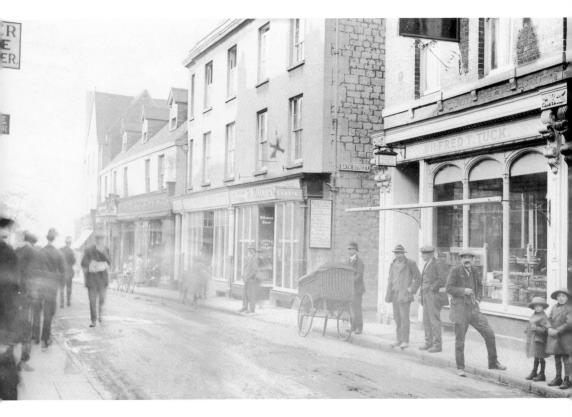

King Street and Bath Street

The clock and the sign for the Merrywalks Shopping Precinct are fixed to the building constructed over the entrance to Bath Street. On the right Eclipse replaces Tuck's confectionery business, parts of the important façade of which were rescued by former museum curator, Lionel Walrond. The shop on the left of Bath Street was a hairdresser's when this postcard was sent in 1922. In the message on the reverse Arthur Mulvany explains to his nephew in Buffalo USA that the postman with the basketwork truck delivers letters and parcels to him each day.

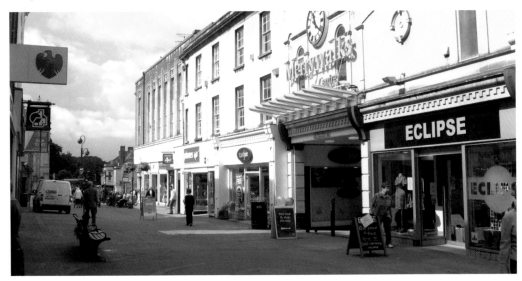

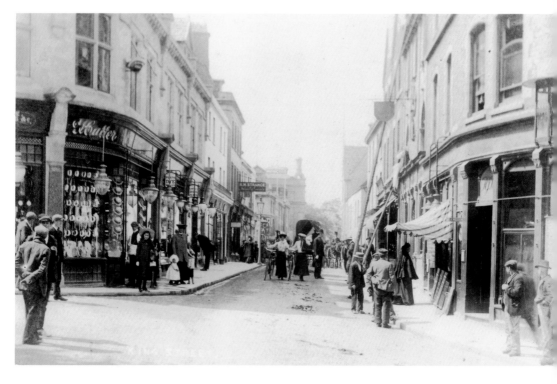

King Street, looking west, circa 1906
C B Gardner's, the hatter's on the left corner, occupied a building only just erected when this Edwardian picture was taken. His shop sign of a hat is fixed to the wall between the upstairs windows. Opposite was Rufus Weston's, a tailoring and breeches-making business. Today this is Subway.

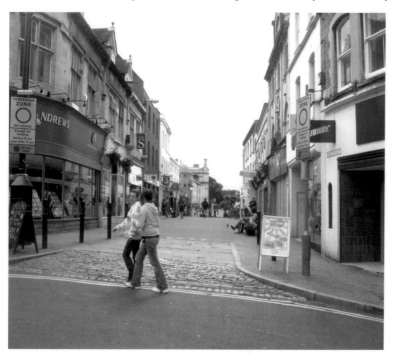

Note that in the early picture the alcove next to Weston's door still contains the clock called the Town Time, now installed in the Library following its expert restoration some years ago by Michael Maltin. Many local people will remember Strange's, the grocer's, further along King Street on the left.

West's Café, King Street
The Second World War picture shows a bread queue and it is a reminder of the hardships of this period which many senior citizens still remember so vividly. During the 1950s the author's aunt was employed at the café as a cook and there were frequent culinary treats of surplus food for schoolboys slipping in at the back door as the restaurant came to the end of its serving day! In the window of 'Reflections' a present-day photographer may be glimpsed – in reflection!

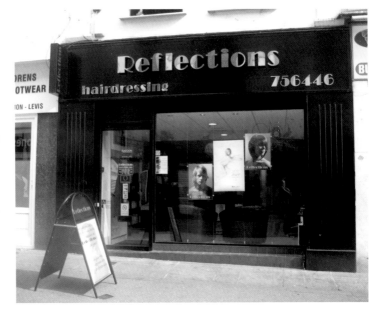

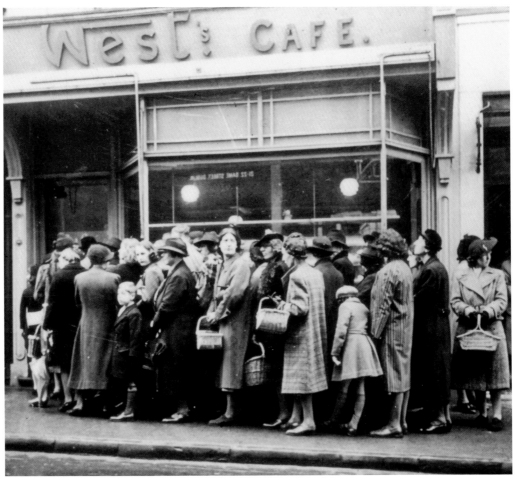

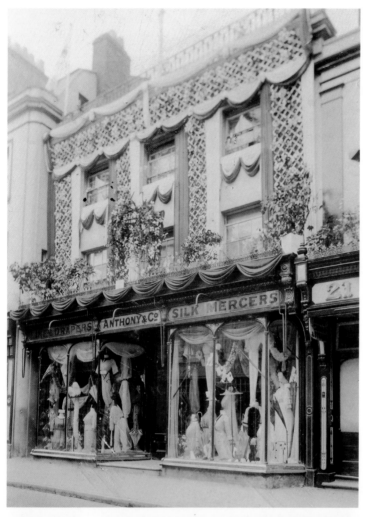

Anthony's Drapery Store, King Street

Mr Anthony was still to be seen enjoying a cup of tea in West's Café well after the last war ended, but this picture of his drapery store dates from a much earlier period. It is thought to show the shop decorated either for the 1911 Coronation of George V and Queen Mary, or for one of the visits to Stroud of the County Agricultural Show in 1907 or 1912.

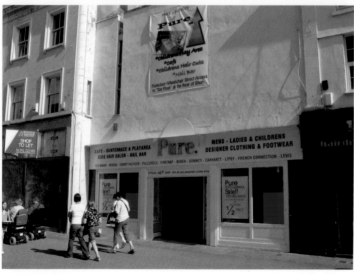

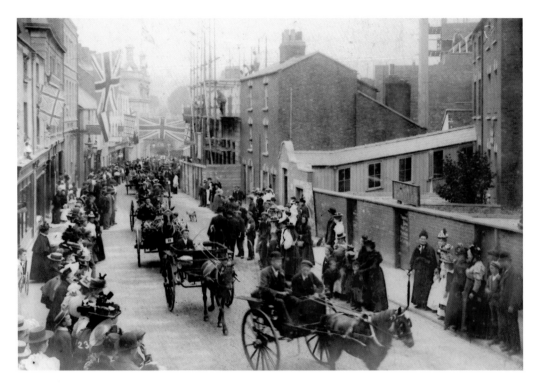

Upper Russell Street

The early photograph is thought, possibly, to record part of the carnival procession for Queen Victoria's Diamond Jubilee in 1897. Note the scaffolding – all wooden poles and rope at that period – on the Wilts and Dorset Bank in the distance. The 'tunnel' on the right was put up to allow thirsty postmen a quick entry into the Post Office Inn, with its main frontage on George Street. The man driving the front trap is the author's great-uncle, H T Pearce, blacksmith, of London Road.

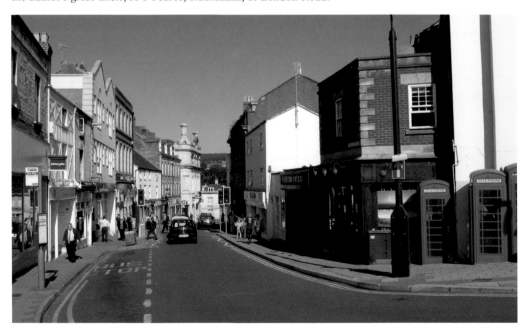

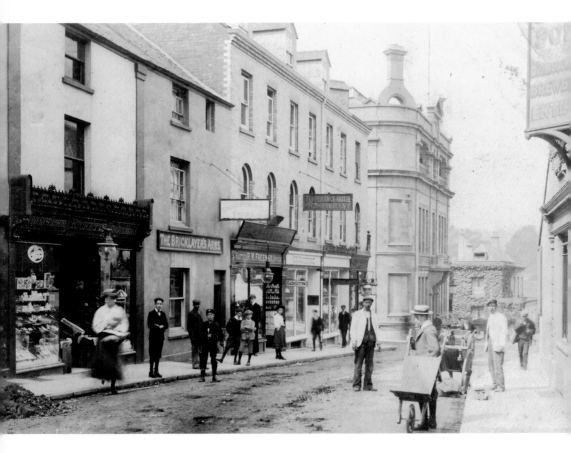

Lower Russell Street, looking down
In this Edwardian picture by William Lee note the Post Office messenger boy by the left kerb and also the number of bystanders who have stopped to observe the young photographer's activities. The pub on the right, now Frowen's Estate Agency, is served by Brimscombe Brewery. Opposite is another pub, the Bricklayer's Arms. Keeping a balance as it were, a couple of doors down there is a Temperance Restaurant!

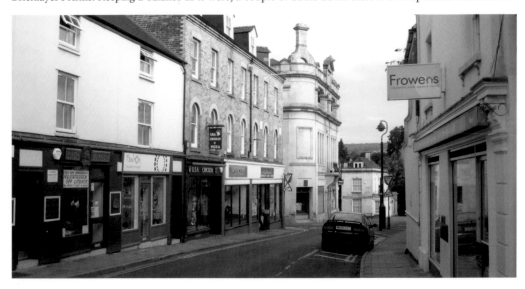

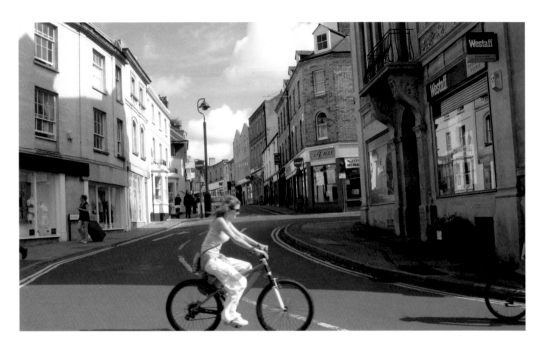

Lower Russell Street, looking up

The earlier picture dates from the 1920s or 1930s. Lewis and Godfrey's drapery store on the left has now been superseded by a shop still selling similar items. Café Max has replaced Boots which has relocated to the High Street. Russell Street was, at this period, like all Stroud's streets, a two-way thoroughfare. Even as late as the 1950s Boots had a sit-on weighing machine operated by that delightful character the late Eileen Halliday from Dudbridge.

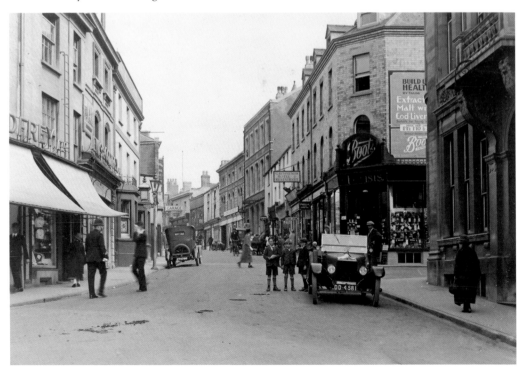

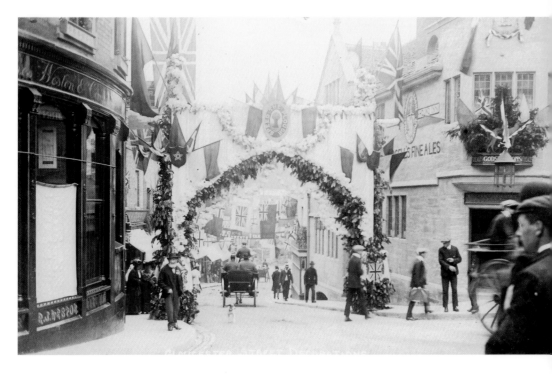

Gloucester Street, looking down

For the visit of the 1907 County Agricultural Show the town's extensive decorations included five arches erected across various streets. Here we see the one at the top of Gloucester Street. Note that the recently built Greyhound Inn on the right is supplied by Godsell's Salmon Springs Brewery. Mostly built in red brick Gloucester Street is a Victorian addition to the town. The earlier parts of Stroud, mainly uphill from the church, were generally constructed in Cotswold stone.

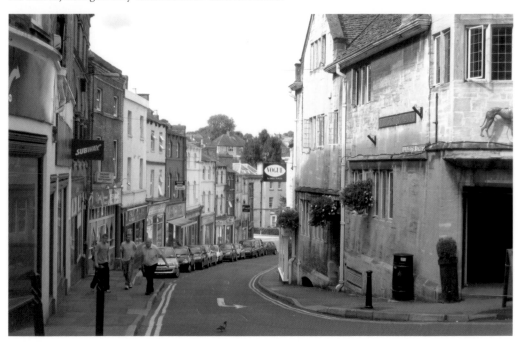

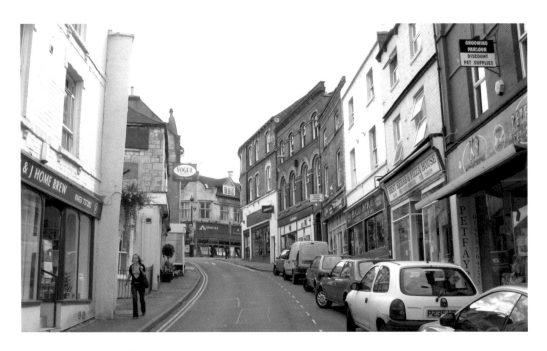

Gloucester Street, looking up

The arch is seen here from its lower side. The occasion may be the same or, possibly, the 1912 Agricultural Show visit, when the arch was re-erected. Interestingly, the barber's shop on the left has not disappeared entirely without trace: a recently discovered advertisement panel has been preserved. In Edwardian days Gloucester Street had a mixed range of businesses. Today the right hand side is predominantly eating establishments.

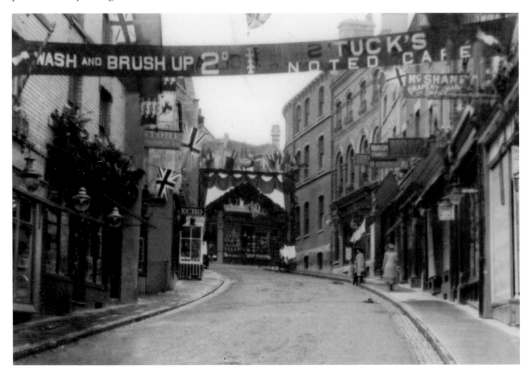

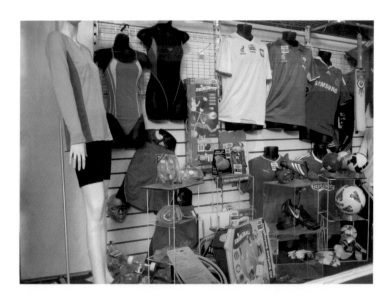

Stroud's Sports Shops

A century ago 21 Gloucester Street was occupied by W J Butcher, who seems to have combined the unlikely occupations of tobacconist and athletic outfitter. Parts of his distinctive shop front have survived. Currently the premises house a hairdresser's, so a more fitting modern parallel would seem to be Bateman's Sports business, near the Four Clocks.

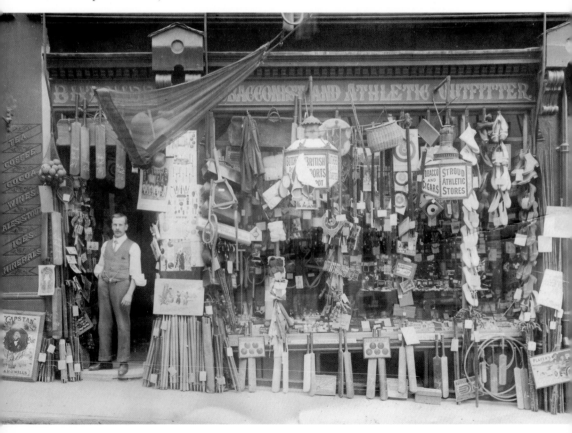

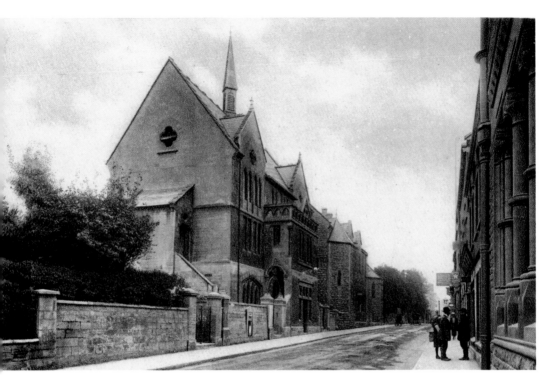

The Old Library, Lansdown
In the 1920s picture we see a street quite devoid of motor traffic. with a section of wall with a hedge and bushes behind, where the later library building now stands. Set into the wall is the Victorian letter-box with a stone surround and pedimented top, which was later repositioned further along the street. In the distance is Lansdown Hall, formerly occupied by the Christian Science Church and now, renamed The Space, serving as a centre for exhibitions, drama and other varied activities. The Old Library, with busts of Milton and Shakespeare on its facade, was opened as such in 1888.

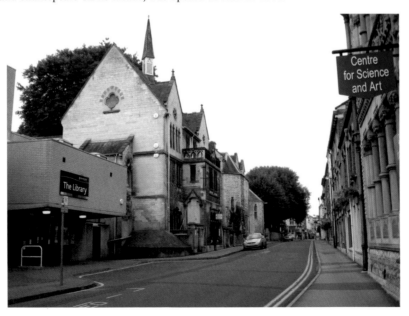

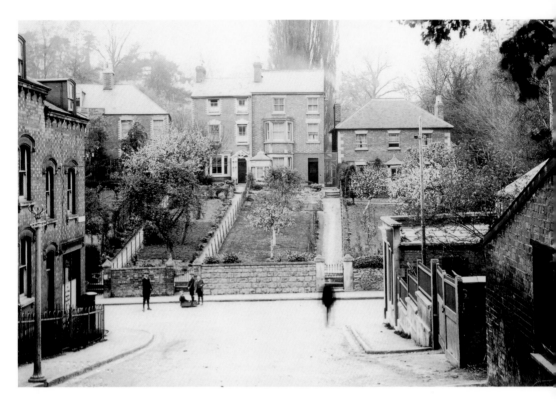

Locking Hill

After a hundred years, the houses in the distance look virtually unchanged, apart from the loss of the lower part of their gardens in order to provide garages. During July 2007 the chemist's shop on the right of the modern picture was inundated with flood water, together with much of nearby Slad Road, where levels reached roughly to the top of the garage doors.

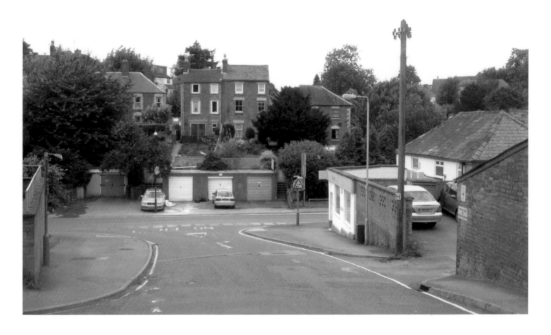

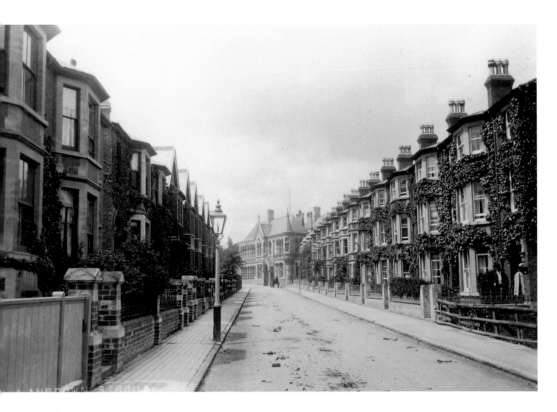

Lansdown

The buildings in this street have changed little in a century. Gateposts and garden walls have mostly been retained, since there was no possibility of constructing garages. However, the modern picture shows a street properly surfaced, but jammed with parked cars. The gas lamp has gone, as has much of the creeper with which people formerly loved to cover their homes.

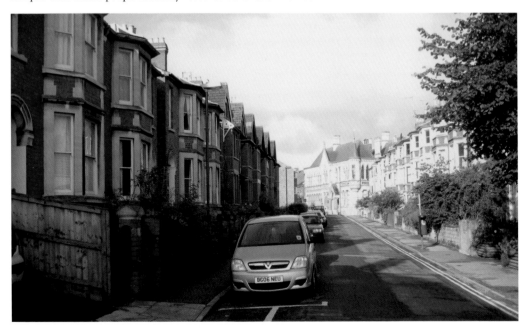

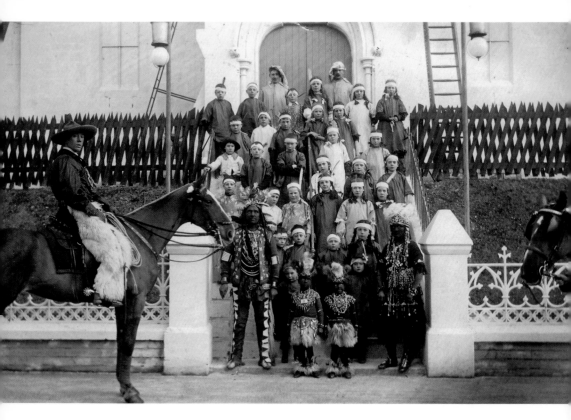

Spot's Cinema

This building in Lansdown, which has served at various times as a Unitarian Chapel, a meeting place for the Liberal Party and a Dance School was, for a while around 1910, the home of the Photo-Electric Playhouse, Stroud's first fixed-location cinema. Its proprietor was Vincent Walker, nicknamed 'Spot', who encouraged attendance by dressing up as a Red Indian Chief (as here, by the left pillar) with a willing crowd of young squaws, braves and mounted cowboys. He also sometimes appeared as an African Chief, accompanied by two young grass-skirted assistants he called Timbuc One and Timbuc Two (seen at the front of the group). What a showman!

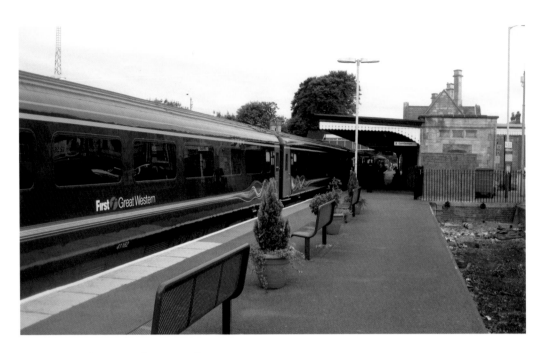

An Excursion from Stroud GWR Station

During the first ten years of the last century the Stroud News (long before its merger with the Stroud Journal) arranged periodic railway excursions, often to the Capital, in order to allow local people the experience of events such as the Japanese Exhibition. This photo is believed to show the departure of one such trip. Note the ladies' hats. The up-line platform has actually changed very little over a century.

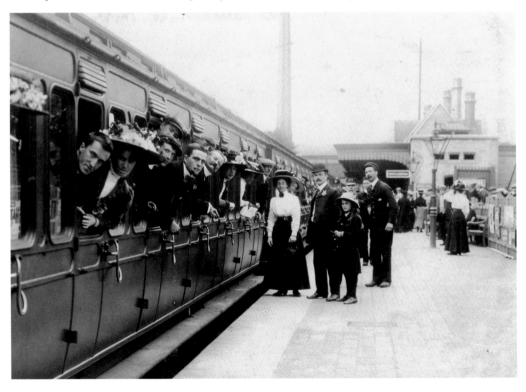

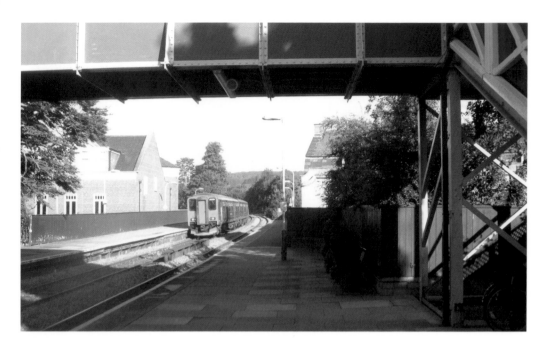

The Railcar and its successor

In 1903 the GWR introduced the first local railcars. Here, probably on the opening day of the service, a railcar is seen at the down-line platform, with its crew and some bystanders posing for photographer William Lee. Note the footbridge before its reconstruction, the signal box and the base of the Stroud Brewery Chimney in the background. In the modern picture the 08.22 pulls away from the same place. The tree on the left in both photographs is highly unusual because it is actually growing through the platform.

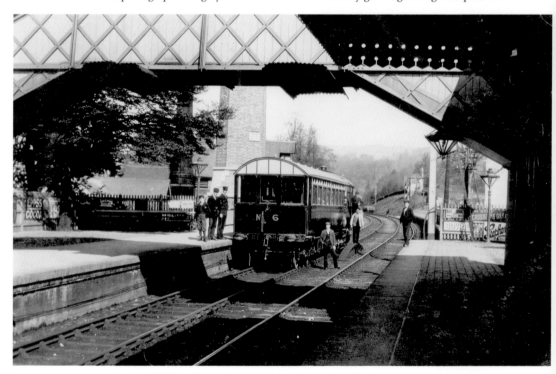

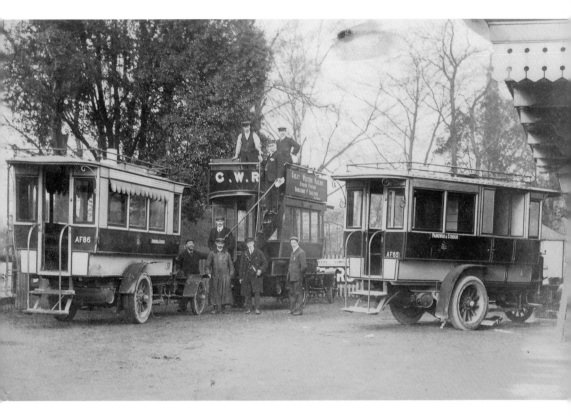

Motor Buses at Cheapside

In 1905 the railcars were supplemented by Stroud's first motor buses, also run by the GWR. Here a group stands parked at Cheapside. The single-deckers have Cornish registration numbers; apparently the Company brought them up from earlier service on the Lizard. Today the waiting room lacks its projecting wooden portico.

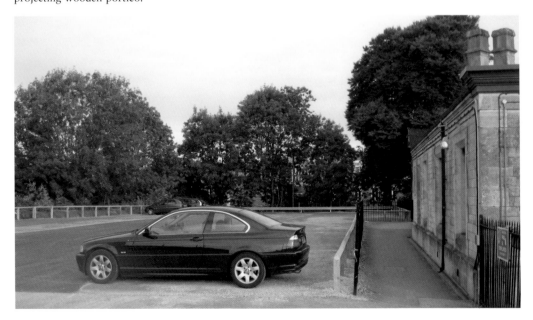

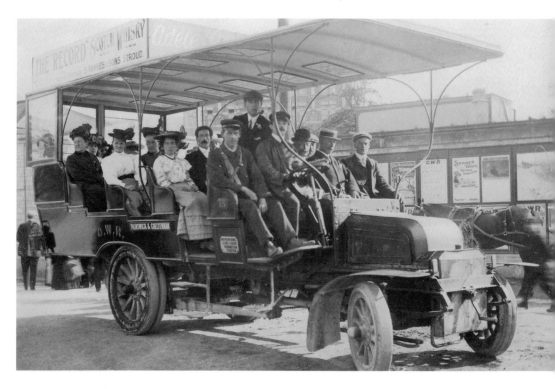

The GWR Station Yard

Here, with a full load of passengers, a motor bus prepares to set out for Painswick – to where a railway line had once been planned – and then on to Cheltenham. The motor bus service of Milnes Daimler vehicles was, in the end, all that materialised. The side panels of this bus have been removed for better ventilation during the summer months. Hill Paul's building, formerly a clothing factory and now flats, is visible in the background. The water tank has long gone.

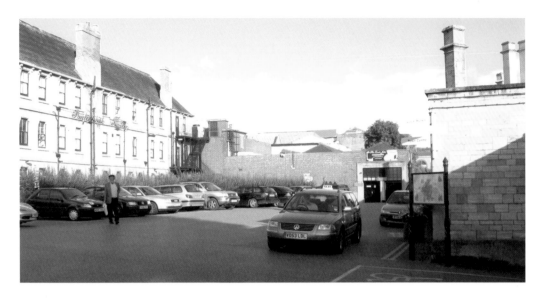

Taxis in the GWR Station Yard
In the earlier picture horse taxis, carriages and a horse bus wait for railway excursion passengers from an Edwardian Stroud News trip. Note that the bushes in the earlier picture have been replaced by a brick building. A present-day taxi driver pauses where his predecessor did a century ago.

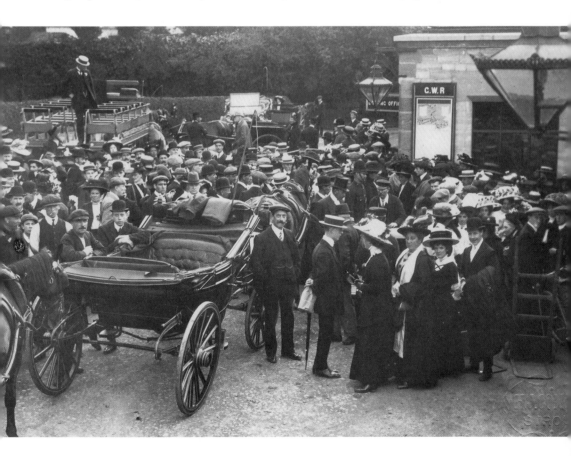

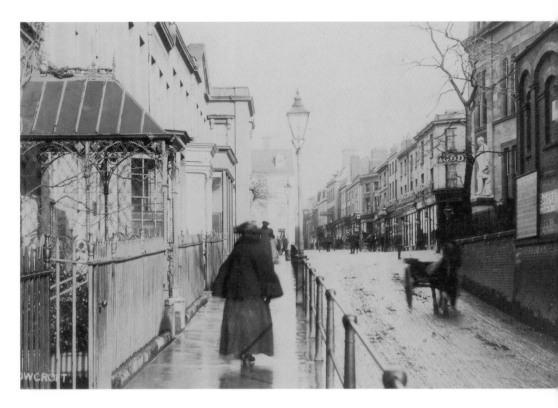

Rowcroft

The later picture no longer shows the decorative porch on the left, or the arcaded building on the right. By 1905, around which time the earlier photo was taken, George Holloway's statue was barely a decade old. The distinctive round-headed railings remain. They were placed there in order to protect pedestrians from the drop in road level, necessitated when the railway was constructed in 1845.

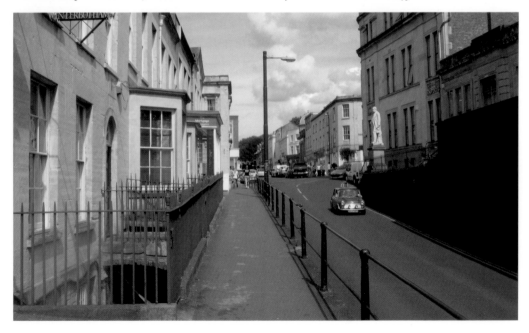

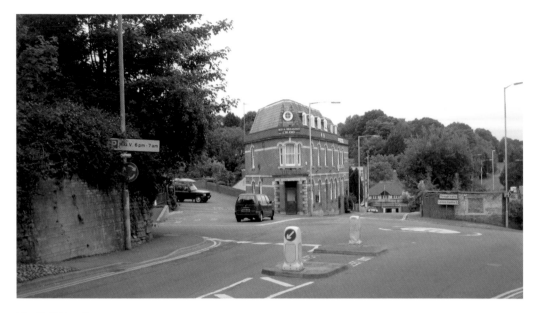

The Bell Hotel

Above the sign on the public weighbridge house on the left can be seen a shield with the initials SLB (Stroud Local Board) and the date 1878. Beyond it this Edwardian view also shows the entrance to the Midland Railway Station. The Bell Hotel was put up to serve the same purpose as the Imperial – each would offer refreshment and accommodation to passengers arriving at the respective stations. Behind the lamp post on the right, part of a building belonging to Stroud Brewery is visible. The lower section of its wall survived until recently.

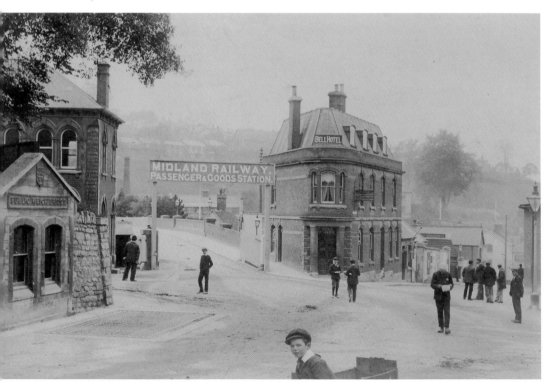

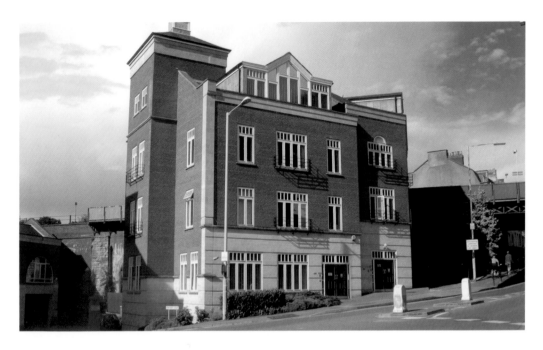

Stroud Brewery

The earlier photo dates from the Coronation of 1953. The writer recalls that the Brewery decorations were illuminated at night and that the wheels of the royal carriage actually turned. He also remembers the pungent aroma of malt that he smelled issuing from the premises while he was walking back each day from Marling School into Stroud. These impressive buildings, following demolition, were superseded by the headquarters of the Stroud and Swindon Building Society.

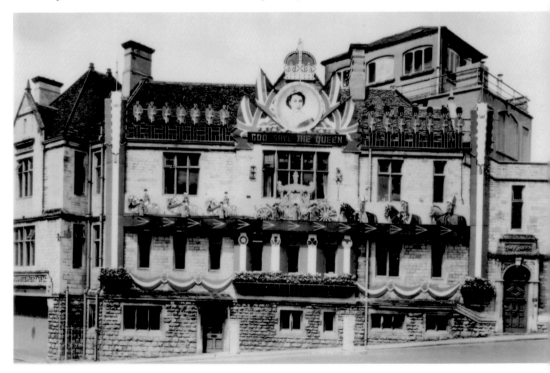

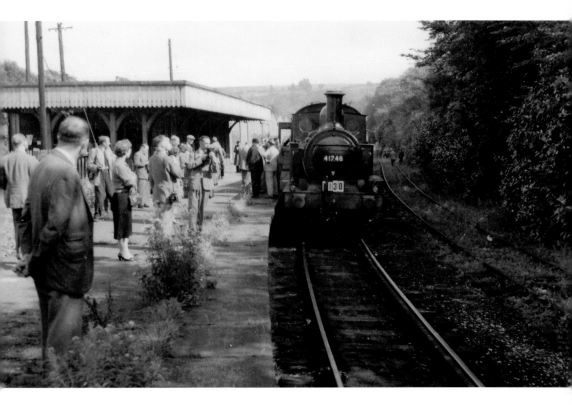

Stroud Midland Railway Station

A line from Stonehouse to Nailsworth was built in 1867, with a branch from Dudbridge Junction to Stroud added in the mid 1880s. The Midland Railway buildings were constructed of wood, which made their demolition quick and easy when the station closed. The line of the track is the path of the present east west by-pass. The earlier photo was taken on 25 August 1956, when an enthusiasts' special was arranged. The line had closed to regular passenger traffic in 1947.

Elephants at Wallbridge

The main A46 Bath Road used to run straight down through Wallbridge. Since the creation of the rather confusing double roundabout, this road leads, for motor vehicles only, to a builder's merchants premises. The early photograph from the 1940s or 1950s shows a troupe of elephants parading into town to advertise the arrival of a circus. The stone-built property behind the animals has gone, but it had a date-stone reading 1714 above the door. Two fine cupboards and some eighteenth century wallpaper from this house are preserved at the Museum in the Park.

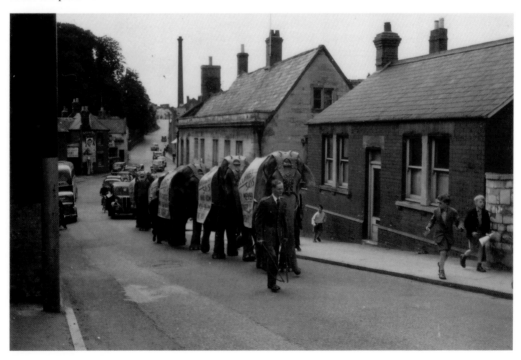

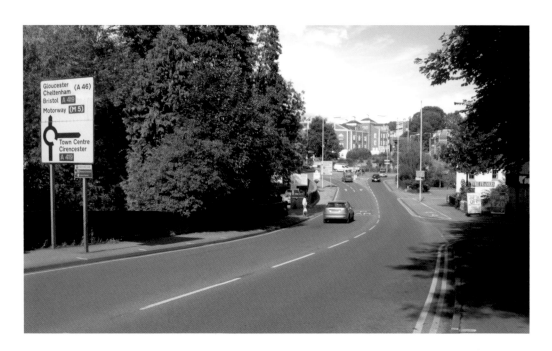

Wallbridge from the south

In the Edwardian picture there is a pub, the Ship Inn, behind the milk cart with its large churn. This building lost its licence around 1912 and, shortly afterwards, was rented by the author's maternal grandfather as a warehouse for the clothing business he operated under the name of Lee Brothers. Also at Wallbridge was a small shop run by the writer's cousin, Emma Lee, née Hallett, grandmother of the poet and author Laurie Lee. On the far left of the earlier photograph, part of the building housing the offices of the Stroudwater Canal Company can be glimpsed.

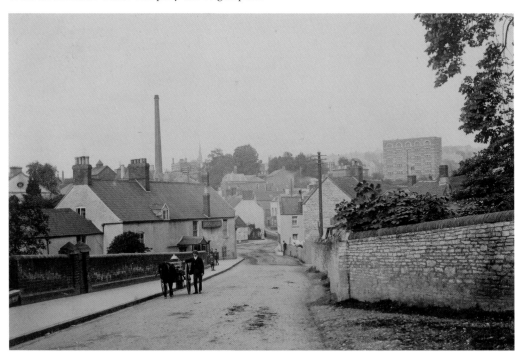

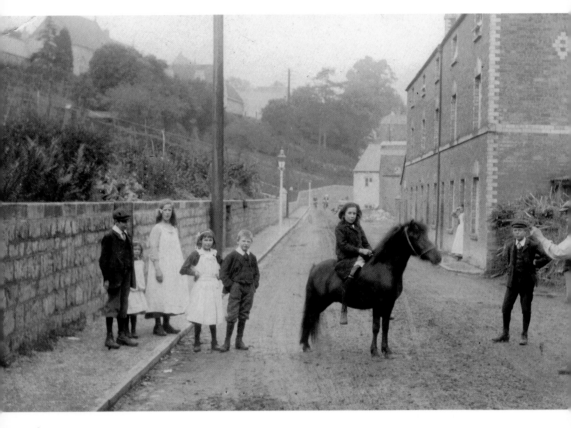

Merrywalks

A transformation took place here around 1960. Before then it was, as the Edwardian view shows, a quiet lane, narrow in places, especially where it joins Beeches Green.

When it was widened to allow through traffic to avoid Rowcroft, King Street and Gloucester Street, most properties on the right side of the road were demolished, a bus station was created – now in turn replaced by the new cinema complex – and the Shopping Precinct and multi-storey car park were constructed. It would be unwise to pose on horseback – or indeed on foot – at this spot today!

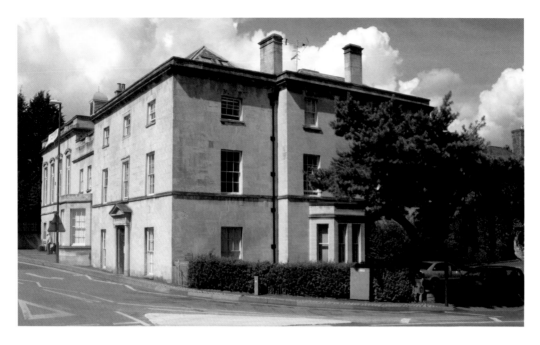

The Old Police Station
The former police station and Magistrates' Court, seen here lavishly decorated for an Agricultural Show visit, is an impressive structure, made even grander by sympathetic extensions added soon after this Edwardian view was taken. Following the move of police and magistrates to their new premises in Parliament Street, these buildings became offices and also the headquarters of the Liberal Democrats.

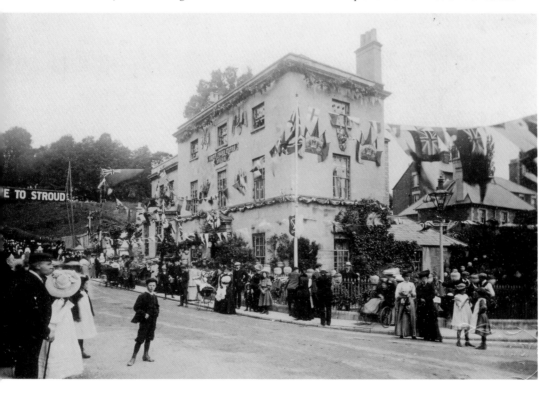

Badbrook House

As with other buildings in the area, Badbrook House fell victim to redevelopment and road widening. In 1914, when this postcard was franked, it housed the main building of St Rose's Special School. At a later date the premises became flats. Today the Merrywalks footbridge terminates in what was then its garden.

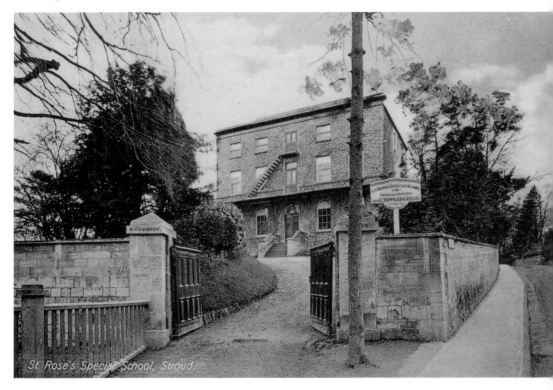

St. Rose's Special School, Stroud.

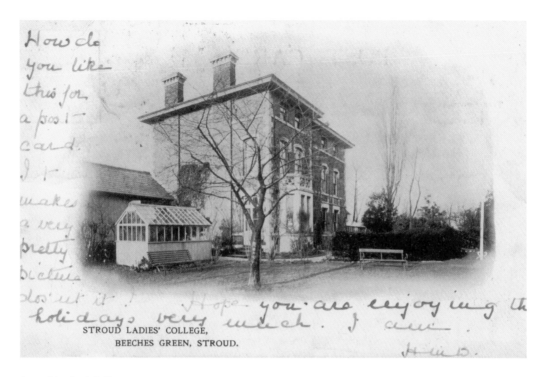

How do you like this for a post-card. It makes a very pretty picture dos'nt it! Hope you are enjoying the holidays very much. I am.

H...s.

STROUD LADIES' COLLEGE,
BEECHES GREEN, STROUD.

Stroud Ladies' College

A century ago all towns and many villages would have had private schools, where the offspring of middle-class families could be educated. The Ladies' College at Beeches Green was such an establishment. Today the property has lost its shed, chimneys, greenhouse and the decorative stonework above its bay window – also, of course, its garden. It now forms part of the Health Centre, the main building of which occupies the right hand section of the modern picture.

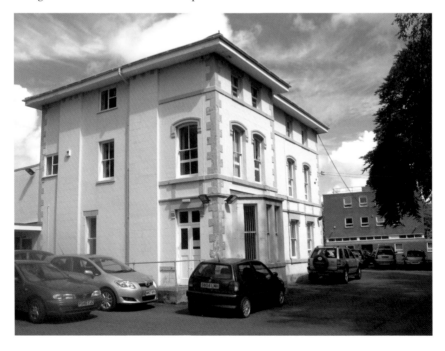

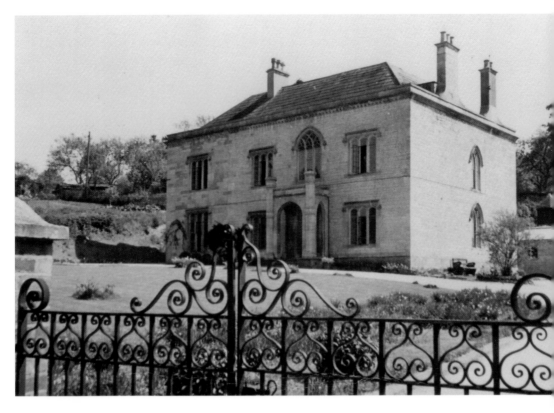

Stratford Lodge

In 1935, the approximate date when the first picture was taken, this was a private dwelling, home to Mr J J Stone. More recently it housed Nelson's School. Much enlarged, it is now a flourishing hotel and restaurant, conveniently placed near the attractions both of Stratford Park, with its successful Museum, and Tesco's supermarket.

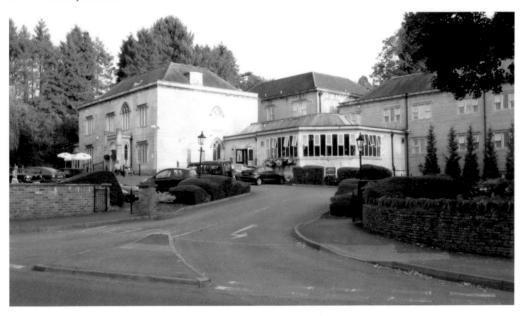

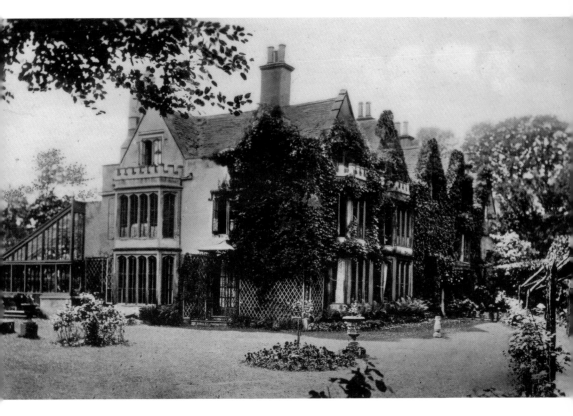

Stratford Abbey College

This establishment was run for many years as a girls' private school by the Isacke sisters, one of whom lived to be a hundred. During the last war it was home to a group of government film makers and was later demolished. Tesco's garage and carpark mark the spot it once occupied. As suggested earlier, its removal was certainly a major architectural loss for the town.

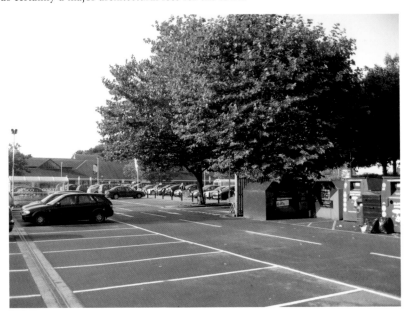

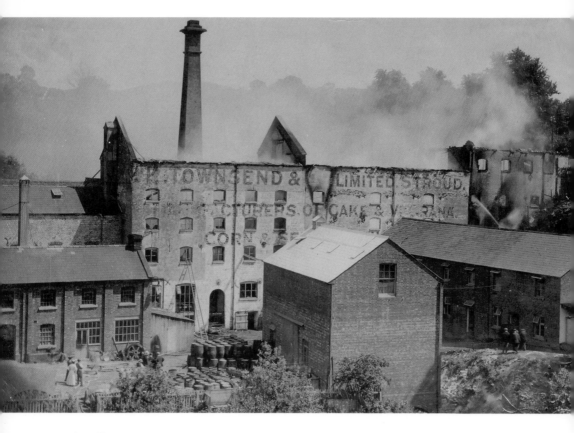

Townsend's Mill

The mill, rebuilt after the fire of a century ago, was eventually demolished and replaced by Tesco's supermarket. The conflagration was witnessed, incidentally, by pupils at Stratford Abbey College who, according to a postcard sent by one of them (a certain Nellie C) were 'up from 1 o'clock in the morning till breakfast. We never went to bed a bit that night because we thought the Abbey was going to catch, but did not.' The mill was listed in a 1910 directory as 'sole manufacturers of the Gloucestershire sheep and lamb food, rapid fattening cake, corn, seed cake and manure manufacturers'.

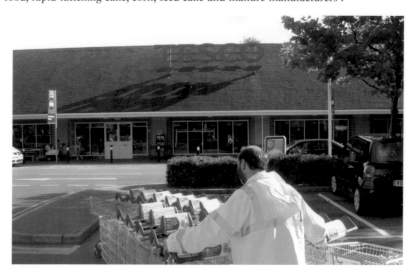

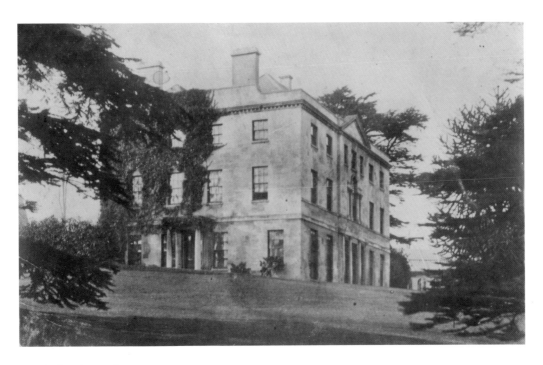

Stratford Park Mansion

Originally the home of the Gardner family, Stratford House was, between 1819 and his death in 1855, the residence of Joseph Watts, under whose control the Stroud Brewery Company rose to unprecedented prosperity. After passing through various hands it became, for a while some fifty or so years ago, a monastic institution housing the Community of the Glorious Ascension. Two of its monks – twins Father Peter and Brother Michael – both rose to become bishops. Now the home of Stroud's splendid Museum in the Park, it has lost its second floor since the Edwardian picture was taken.

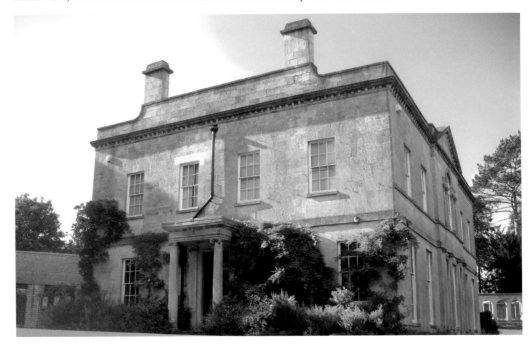

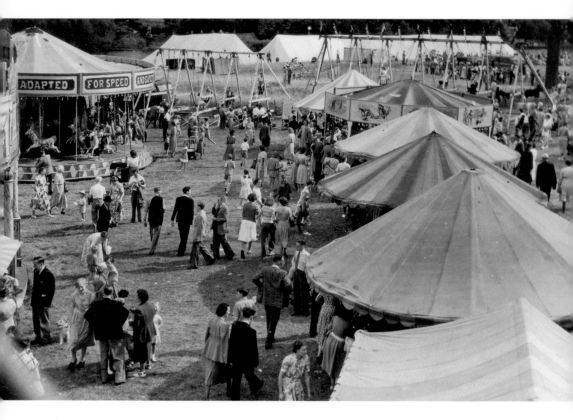

Stroud Show

The earlier picture dates from the 1950s and was taken by that great enthusiast for fairs and circuses, the late Lionel Bathe of Nailsworth. The present day photo shows the 2008 event, ably run by Edna Powell and her team, following cancellation the previous year owing to flooding.

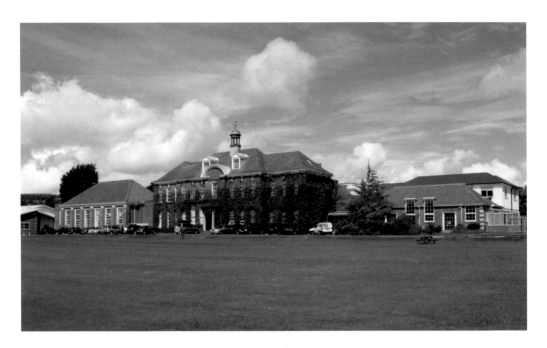

The High School

Stroud High School for Girls began in rooms at the School of Art in Lansdown in 1904, its first Headmistress being Miss D M Beale, niece of Dorothea Beale, founder of Cheltenham Ladies' College. The school moved into its new premises in 1911, just about the time the earlier picture was taken. Note today the additional buildings to be seen on both sides of the main block, the Hall on the left erected in 1937-39 and the Domestic Science room and kitchen put up in 1927. The modern picture was taken on 14 August 2008. In the distance, girls are just visible collecting their A-level results.

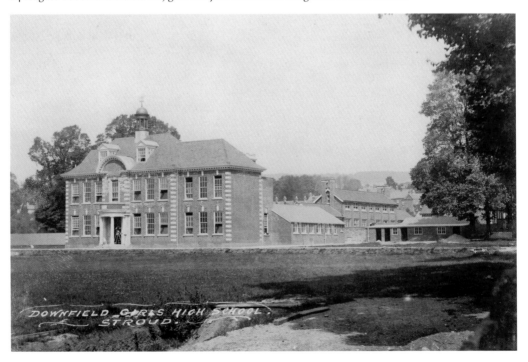

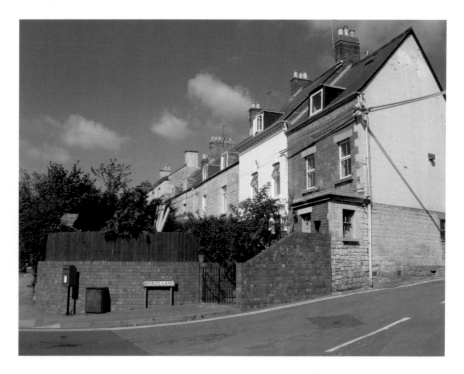

The Downfield Tuck Shop

Until its demolition in the 1950s, this little shop was, not surprisingly, well patronised by pupils from all four Downfield Secondary Schools - Marling School, The High School for Girls and the two Secondary Technical Schools. Its removal did, however, have one positive effect: better vehicular access into Beard's Lane.

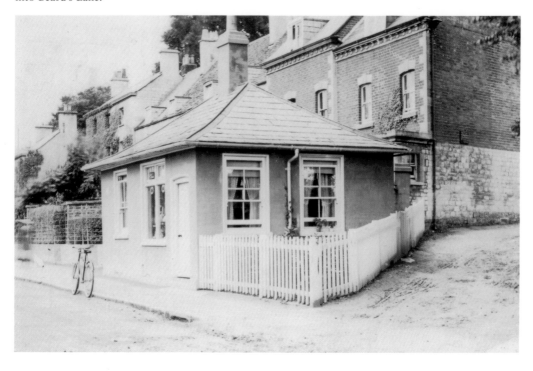

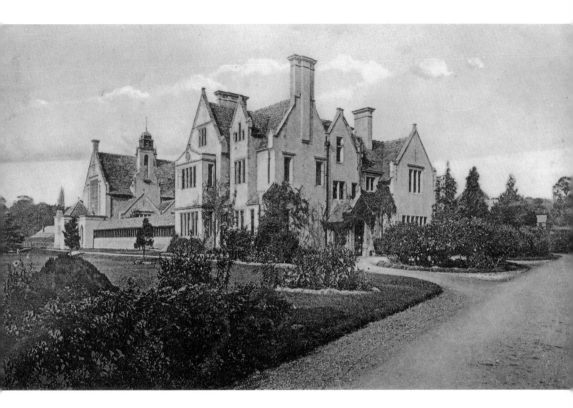

Marling School

The growth of mature trees prevents an exact modern parallel for this Edwardian postcard, written in 1904. A century ago the right hand portion of the complex – joined to the School Hall by a covered way – was the Headmaster's house, with accommodation for boarders. By the 1950s, when the author attended the school, boarding had long been discontinued and the building contained the library and, above it, a classroom, both approached from the open courtyard behind the covered way.

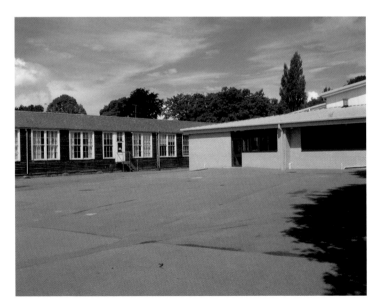

Marling School was founded in 1889. So little has altered here that, to match it, a modern picture has been chosen of another area of the school. The Long Corridor was put up, as a temporary structure, in 1919 and is still very much in use today. How it contrasts with the new Design and Technology building!

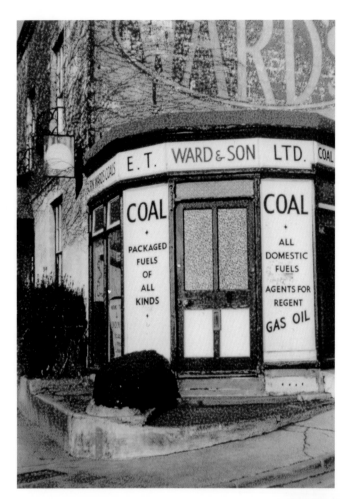

Ward's Coal Office
At the junction of Union Street with London Road is a stone-built house which, during the 1930s, was the residence of the author's grandfather, W E Beard. From here he ran his building business, which closed following his death in 1940.

In the post-war period the house was turned into flats, his showroom became Rock's Café, a haunt for the young, and one room with a wooden extension was let out to E T Ward as an office conveniently placed for access to the GWR Goods Yard. Many will remember the huge lump of coal concreted into the pavement near the door. This was another object later rescued by Lionel Walrond.

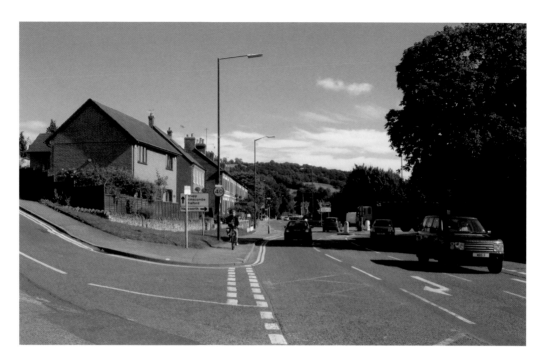

London Road

For some reason the photographer who took this 1907 picture decided to caption it Bowbridge Road. How the scene has changed today! Gone are the trees on the left; new houses have appeared on the near side of Lower Dorington Terrace and a petrol station has been built in the distance. Most obviously of all, a large traffic roundabout now occupies the middle ground to the right – and wise children no longer pose in the centre of the road!

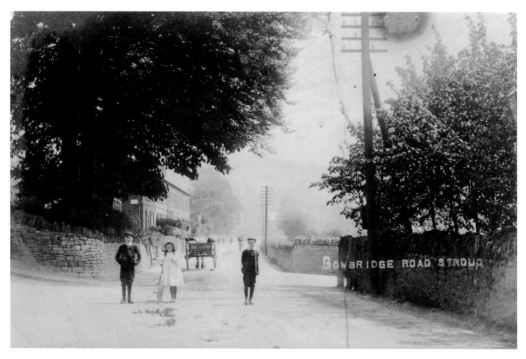

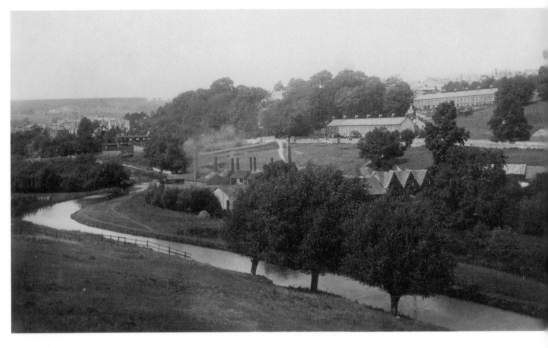

The Canal

This postcard of around 1905 shows the canal taken from Butterow Hill with Arundel Mill buildings in the middle ground and Upper and Lower Dorington Terraces on the slope to the right. A century on the whole area has become so overgrown with bushes and trees that the canal seems to have virtually disappeared and even the Terraces are obscured. An interesting contrast!

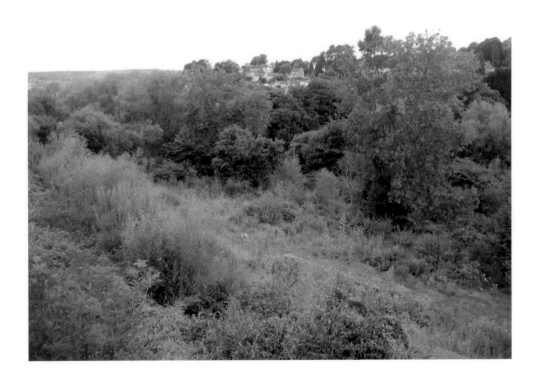

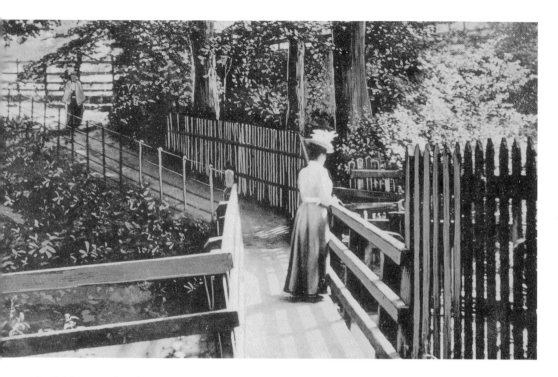

The Bridge over the River Frome

This bridge provides pedestrian access across the River Frome at the Railway Viaduct just east of Stroud. The metal railings have mostly gone and timber has been replaced but, this apart, surprisingly little has altered. The ladies in the Edwardian picture would surely be puzzled by people wasting good paint meaninglessly on walls...

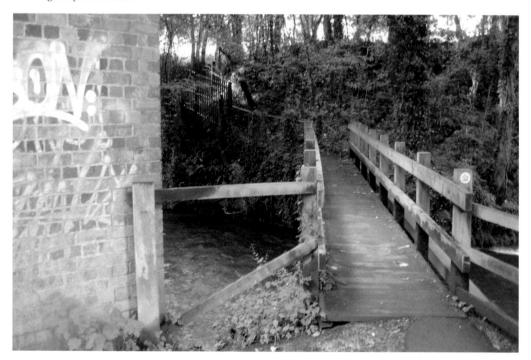

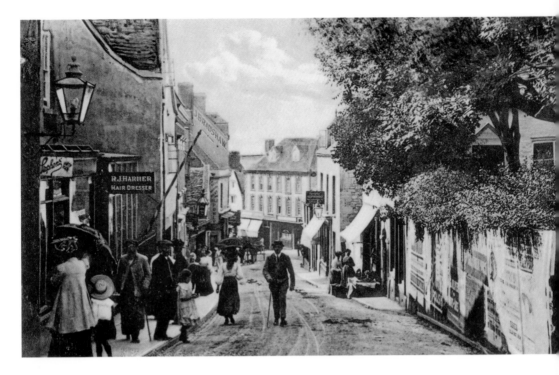

Nelson Street

The building on the left, from which the projecting shop front has recently been removed, is easily recognisable in both pictures. Visible through the trees to the right is part of a row of early cottages, formerly an inn, sadly demolished some years ago. The most obvious difference, however, is the Corn Exchange in the distance, now replaced by the modern shop which was for some time the premises of R Lewis and Co who sold electrical goods.

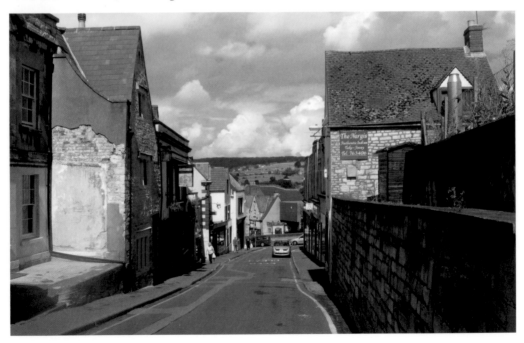

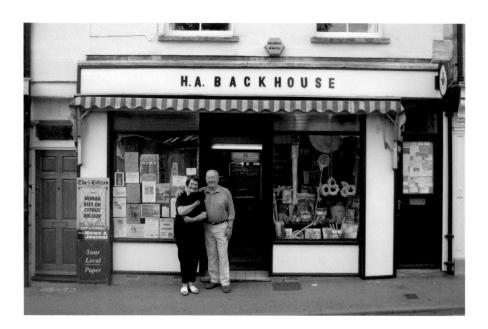

Backhouse's Shop

This popular newsagent's at the lower end of Middle Street still occupies the same premises it did a century ago, when Mr Backhouse posed with his family in the now relocated doorway. As his shop signs make clear, in those days the business also sold hardware and fancy goods. Today Backhouse's must be one of the town's longest established concerns. Its decorative, frequently changed window displays are much appreciated by both customers and passers-by.

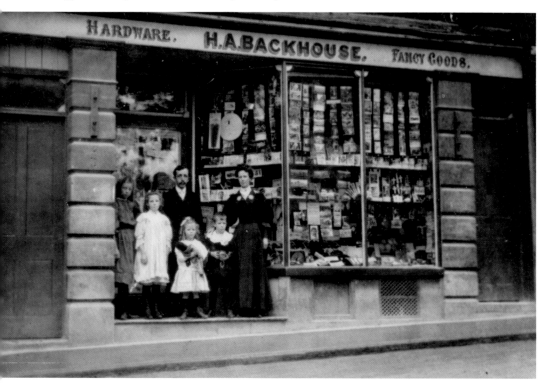

Acre Street

Nothing remains of R B Martin's shop at 11 Acre Street, pictured here at the turn of the last century. Most of the upper part of this side of the street was demolished and access to Chapel Street reduced to a pedestrian archway.

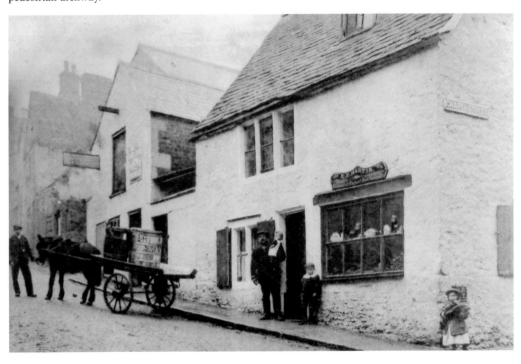

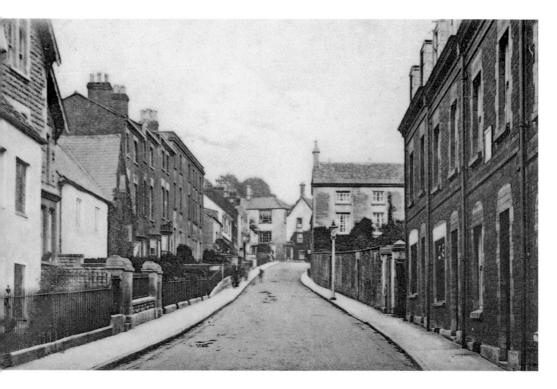

Middle Street

As with most urban streets, a comparison between pictures taken a century apart involves traffic, double yellow lines, loss of metal railings and street lighting. These differences apart, Middle Street has changed rather less than many of Stroud's thoroughfares.

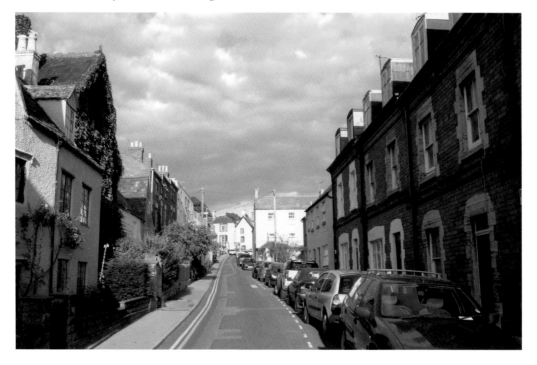

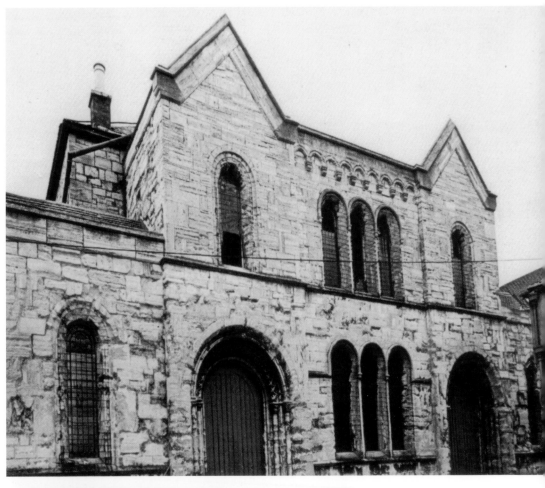

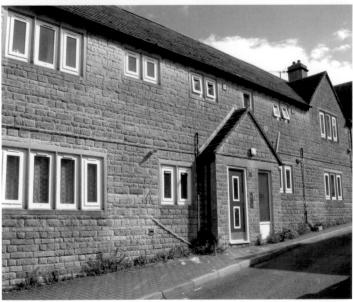

The Old Chapel
Stroud's earlier
Congregational Church –
so-called to distinguish it
from Bedford Street Chapel
put up in 1837 – was erected
in its original form in 1711.
It was later re-fronted in
neo-Norman style. By the
1970s diminishing numbers
of worshippers had made
two chapels of the same
denomination impracticable
and the older one was taken
down. Its Sunday School
building survives as a
Pentecostal place of worship.
The Old Chapel itself has
been replaced by housing.

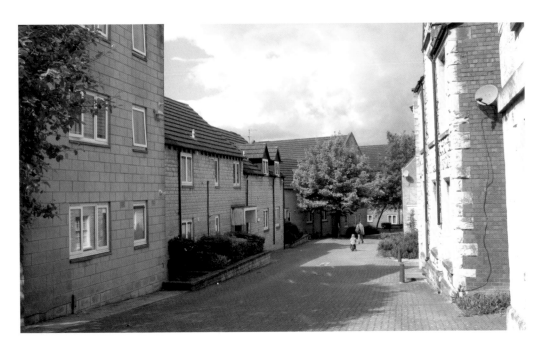

Chapel Street

As this damaged, but interesting, photograph shows, Chapel Street was formerly important as it contained the Headquarters of the Stroud Co-operative Society. Some local branches were served from here, many more by the Cainscross and Ebley Society. The latter's warehouse at Ebley was well-known to the author who spent several 1960s summer student vacations loading wholesale orders there. The Chapel Street premises were razed to the ground and replaced by residential buildings.

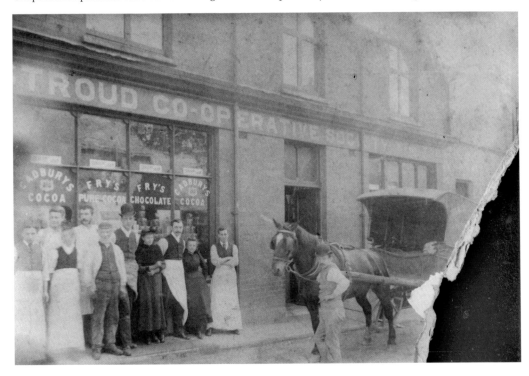

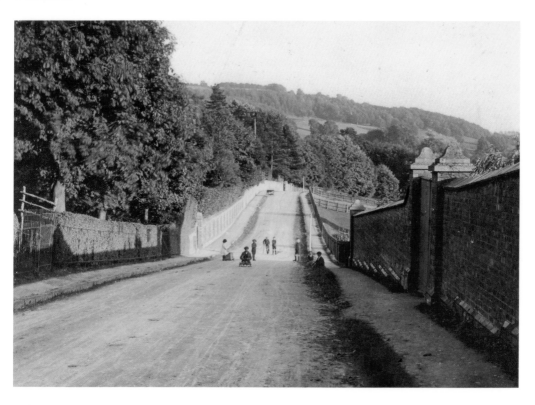

Park Road

The brick wall on the right is the same in both pictures, though the gateposts have at some time been reset rather further in to allow easier vehicular access. On the left the long wall has been breached to allow Southfields Home for the Elderly, and other buildings, to be erected. The fields on the right are now occupied by houses put up fifty or so years ago.

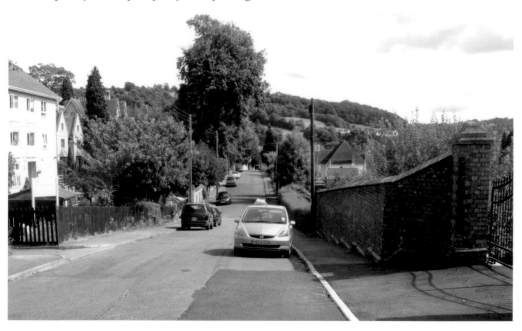

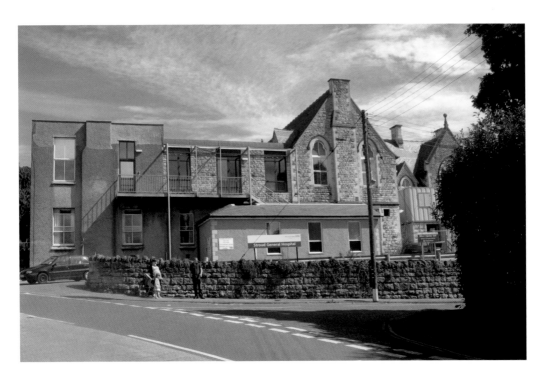

Holy Trinity Church and the Hospital

Holy Trinity Church has lost the twin turrets which topped its western end. The extension on the left of the Hospital, with its steeply pitched roof covered in decorative tile work, was demolished in 1919 to be replaced by the Peace Wing, housing the Hospital's A and E department. Behind the railings on the right may be glimpsed a corner of William Cowle's private observatory.

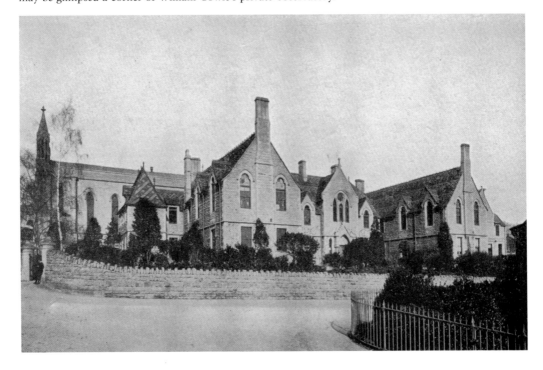

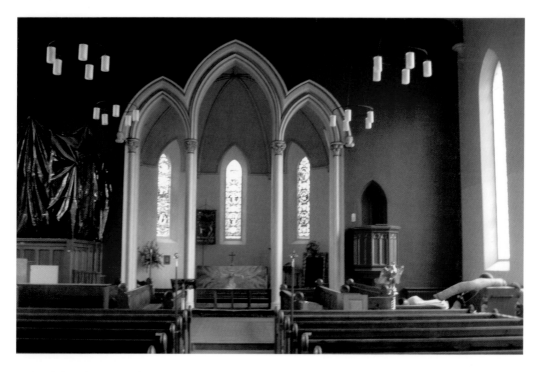

Holy Trinity Church Interior
Now obscured by maroon paint, the important Victorian murals which once adorned Holy Trinity's interior appear clearly on this postcard view of around 1910. In 2008 the church underwent a programme of repairs, which explains the machine on the right and the covering over the organ.

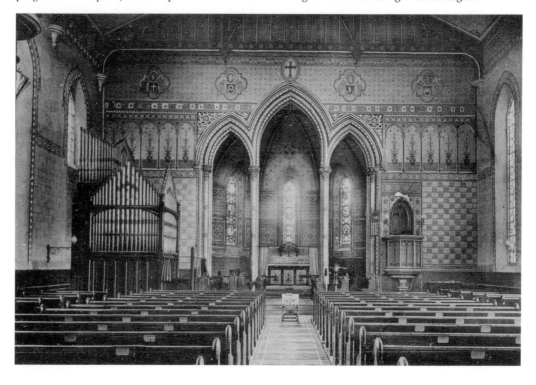

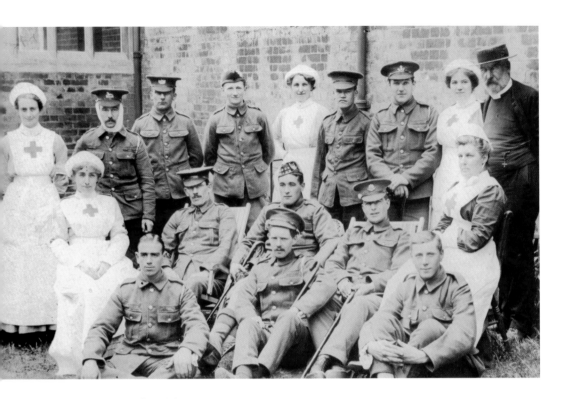

Wounded Soldiers at the Trinity Rooms

From 1914 to 1919 the Trinity Rooms in Field Road served as a VAD Hospital (Voluntary Aid Detachment). Because of the huge numbers of wounded soldiers returning from the Front, general hospitals could not cope, so extra beds were needed. Note the vicar, Rev E H Hawkins, standing on the right in the earlier picture.

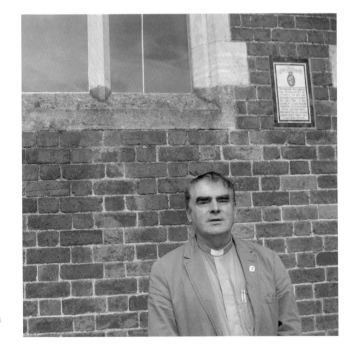

In its modern counterpart the current vicar, Rev M Withey, is next to the plaque which records the building's wartime use. Other similar institutions were set up at Chestnut Hill House in Nailsworth also at Standish.

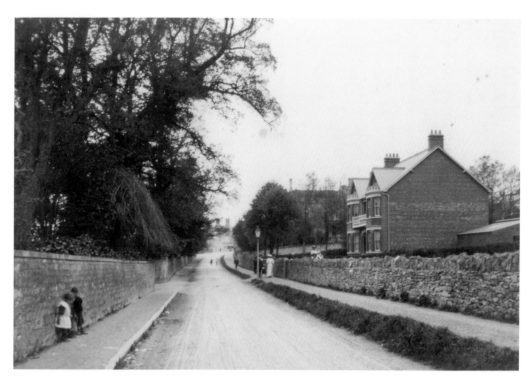

Bowbridge Lane

In 1907 this early postcard was sent all the way to Manchester! The difference in pavement levels, plus the grassy verge, is immediately noticeable. More recently houses were erected on the right as well as the large building, formerly the Nurses' Home, beyond the double-gabled house.

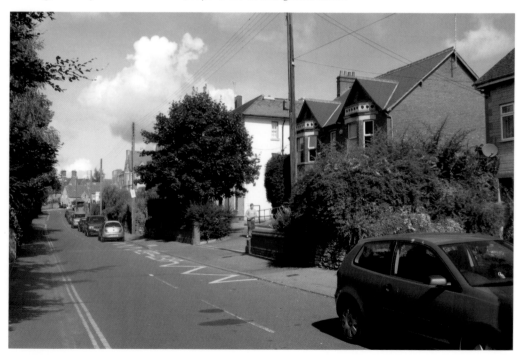

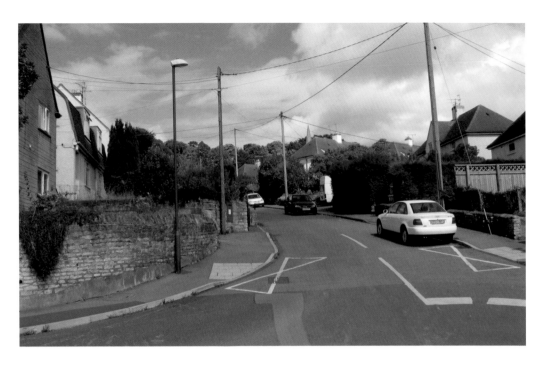

Spider Lane

Judging from the window with its Cotswold dripstone on the house in the early photo, quite an ancient building evidently once stood here in Spider Lane. It may be that the property was already derelict when the picture was taken, possibly around the 1920s. Few scenes shown in this book have changed as much as Spider Lane: were it not for the distant Cemetery Chapel, it would be very difficult to identify the location.

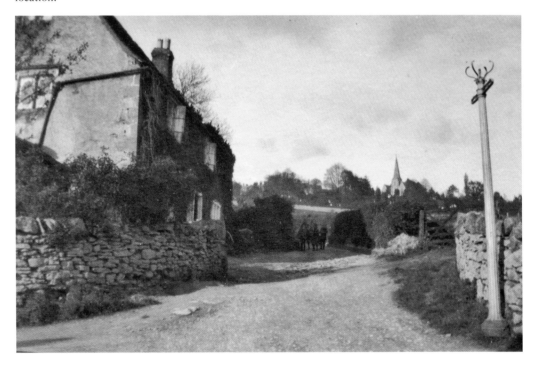

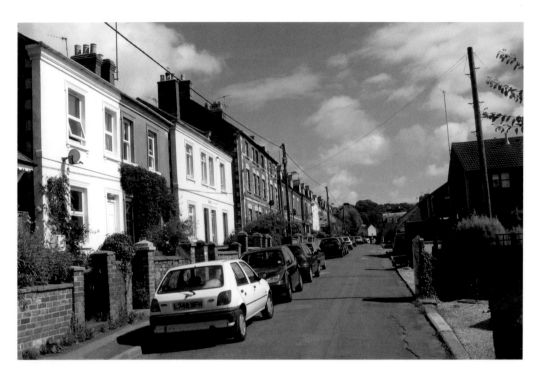

Horns Road

Owing to problems of space, putting in garages has not been possible in Horns Road so, over a century, the differences between the two pictures are relatively minor – bushes here, a gate pillar there. The house on the left, however, has seen more basic alterations, as has the right hand side of the road. It has to be said that car parking, although essential for residents, does little to improve the appearance of a street.

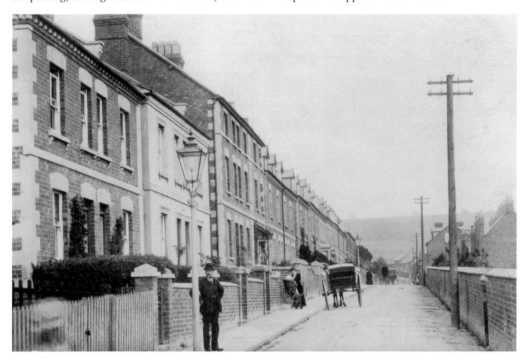

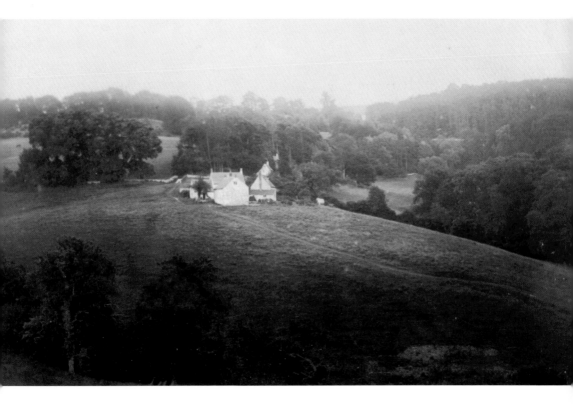

The Lost Hamlet of Weyhouse
A footpath runs down the side of Stroud Cemetery, crosses the stream, then rises up the opposite hillside. At the point where it levels out is the lost hamlet of Weyhouse – or Wayhouse as photographer Mark Merrett spelt it around 1910. A few stones are all that remain of the houses visible on his picture. To all intents and purposes the hamlet has vanished – abandoned, perhaps, because of its remoteness and distance from mains services.

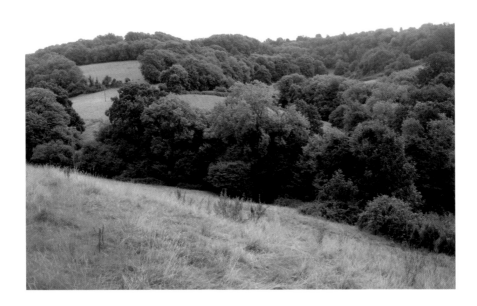

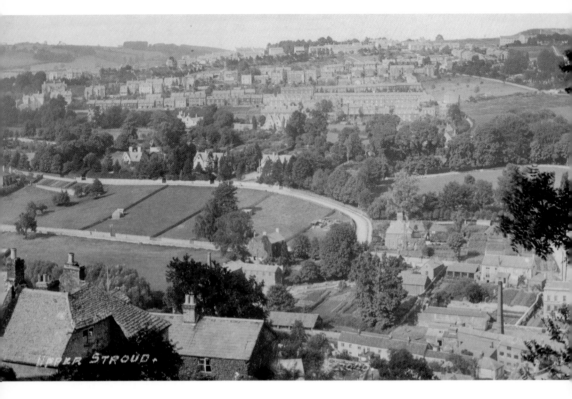

Upper Stroud from Butterow

It has not proved possible to take a modern picture from the exact spot where the Edwardian photographer stood to take this view, nor to avoid poles and cables, but we still see enough of distant Stroud to be able to observe many differences: Park Road's southern side and all of London Road have been developed. Extensive house construction has also taken place around Bowbridge Lane. The large edifice in the bottom right hand corner of the Edwardian photograph still stands on the lower side of the present day traffic lights. Many of the industrial buildings near it have disappeared, or been modified.

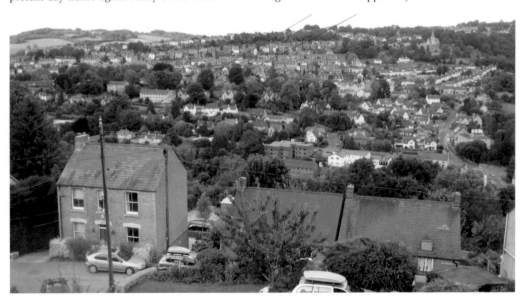

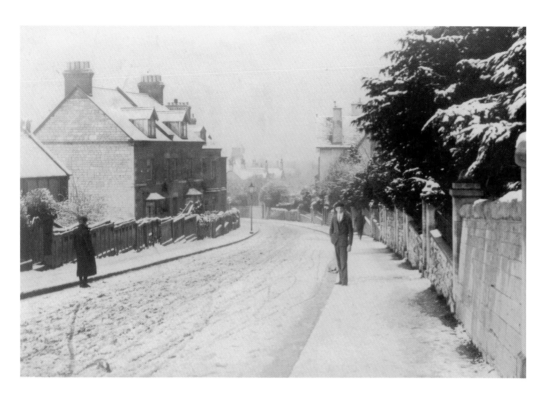

Bisley Road

This snow scene was taken during the winter of 1903 to 1904. Apart from the contrast in seasons between the two views – and the motor vehicles, of course – the detached house with the bay windows provides the other point of interest: it isn't there on the snow scene. The stone eagle on the roof of the building on the far left – which is just visible in the Edwardian view – is common to both. The earlier picture is a reminder of the harsh winters familiar to our forebears.

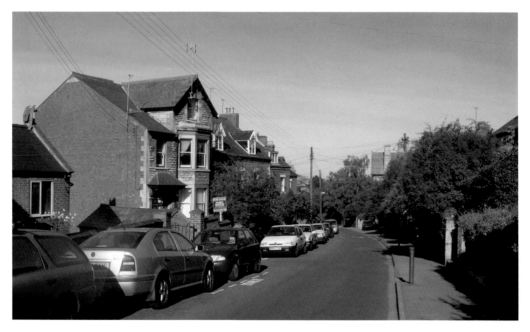

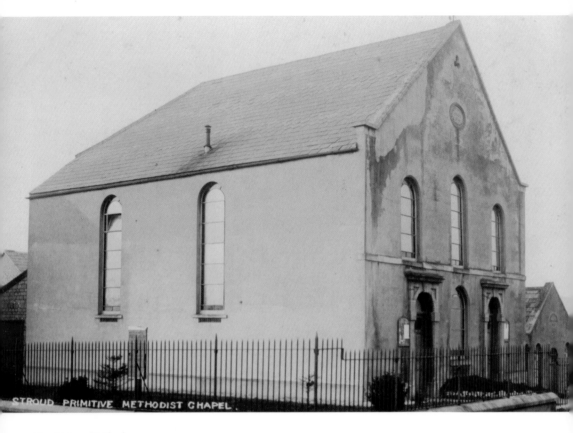

STROUD PRIMITIVE METHODIST CHAPEL.

The Cotswold Playhouse

Methodism came to Stroud in 1763 when the denomination's first chapel was erected in Acre Street. It is now the home of the Salvation Army. During the following century the Primitive Methodists built a chapel of their own in Parliament Street.

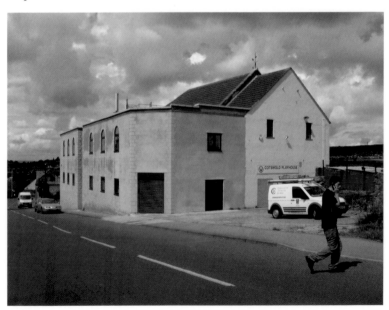

In the 1950s, by then no longer needed, it was converted into the permanent home of the Cotswold Players, whose productions had previously been staged mainly in what was then called the Church Institute in the Shambles. Following a recent extensive second enlargement, the theatre, complete with extra rehearsal and meeting rooms, would appear to have a bright future.

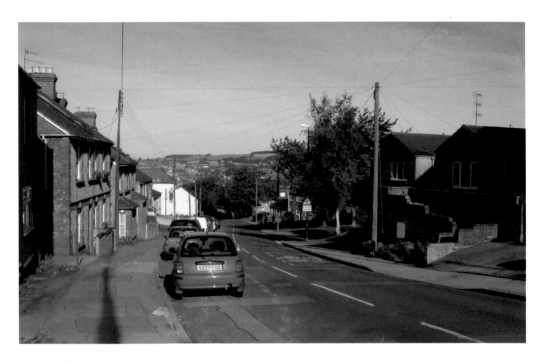

Bisley Old Road

When widening takes place usually only one side of a street is affected. The houses on the left – all the way down as far as can be seen – look the same today. But on the right hand side everything has been swept away, including the Spread Eagle Inn. Thus a relatively narrow road becomes a wide thoroughfare.

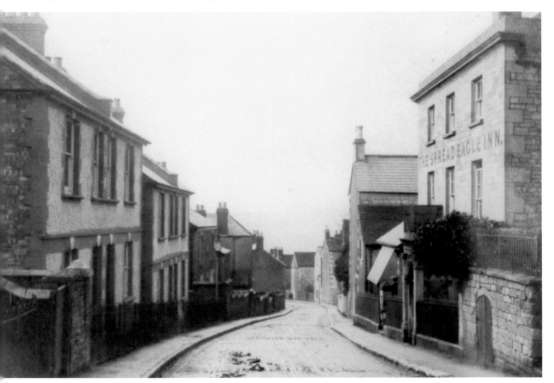

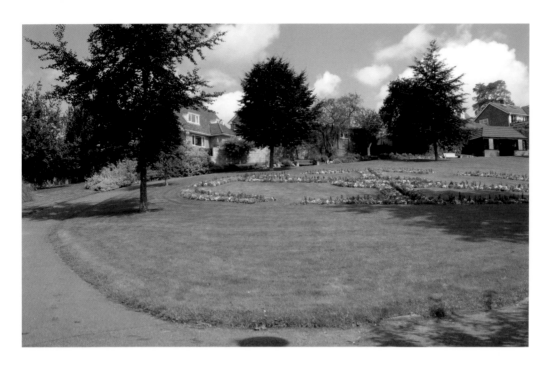

The Park Gardens

On an Edwardian photograph earlier in this book Sidney B Park's drapery store can be seen on the corner of George Street and King Street Parade – curiously right next door to its rival, Lewis and Godfrey's! Mr Park's only son was killed in France in 1917 and these gardens were given in his memory to the people of Stroud a decade later. Not a great deal has changed here. Even the borders seem much the same, although the rockery has gone and modern buildings can be seen in the distance.

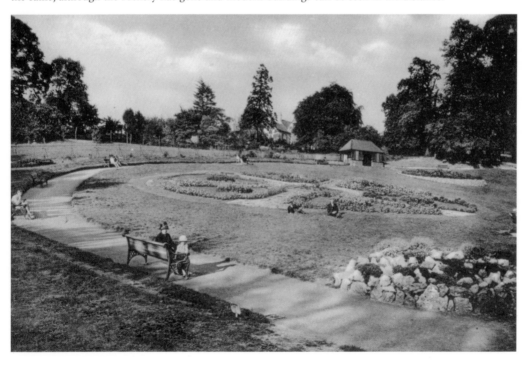

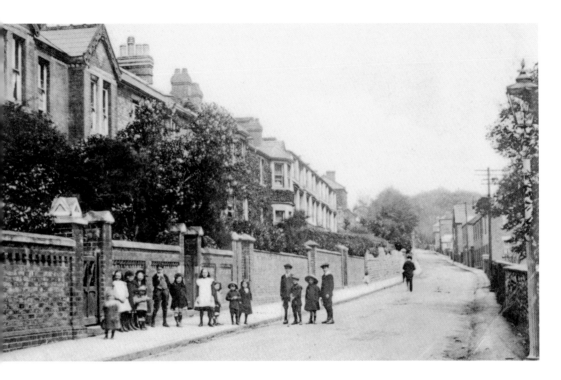

Slad Road, looking up

A century ago the interest people showed in the visit of a photographer had not been diminished by the availability of cheap cameras. Here we see a dozen or more youngsters eager to be immortalised in Fred Major's picture postcard view of Slad Road. Publishers, of course, realised that the more children in the foreground, the more copies were likely to be sold. Surprisingly little has changed in Slad Road over so many years, except that the wall on the right has been opened up to allow access to new housing.

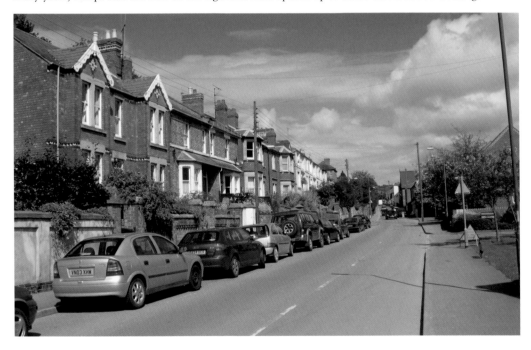

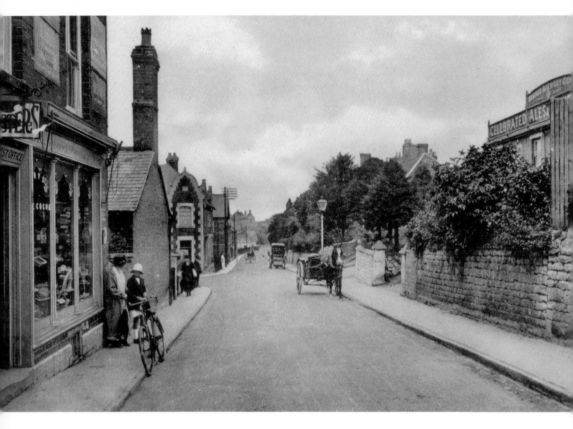

Slad Road, looking down

The Fountain Inn on the right remains a pub, but without its decorative rooftop advertisement boards. The shop on the left of the older picture was evidently, for a while, Uplands Post Office. When this was is unclear although the clothes worn by the people would suggest the 1920s or 1930s.

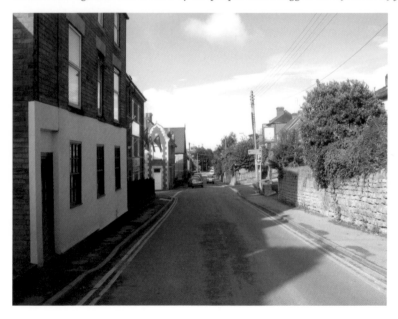

The corner building on the left, beyond the road junction, was formerly a branch of the Co-op. In Laurie Lee's 'Cider with Rosie' the manager, upon hearing Annie Lee's bicycle bell, would rush out from this front door to catch her as she careered down the slope from Slad!

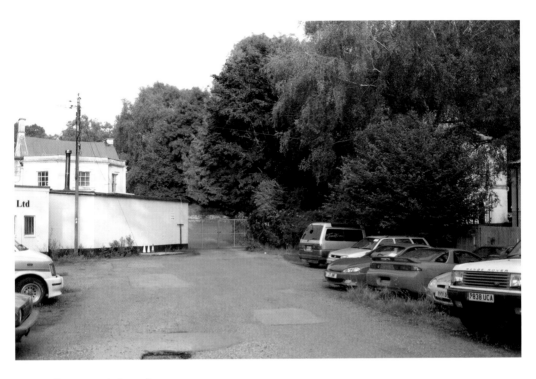

New Mills Court, Slad Road

Around the time this century-old picture was taken New Mills Court was occupied by Mr Thomas Bullivant. The subsequent fate of his attractive mansion must surely have caused stirrings in his grave, for the whole of the centre portion and the inner part of the right wing of the house have simply disappeared. In addition the left bay has had an ugly factory building grafted onto it.

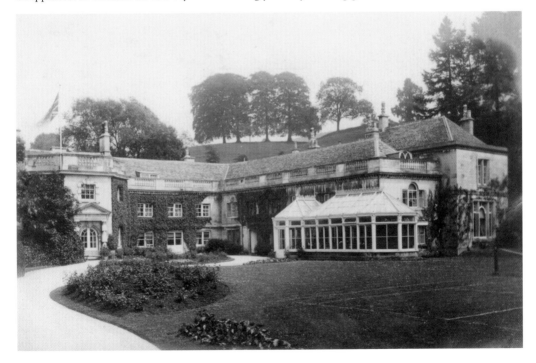

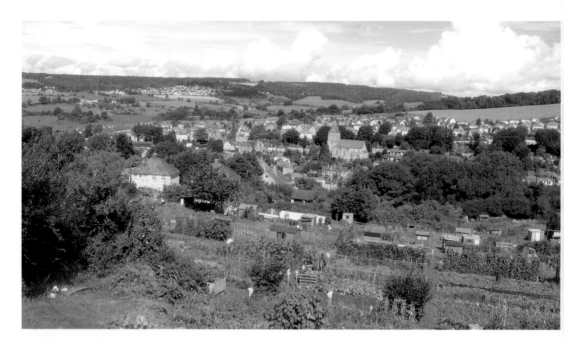

A distant view of Uplands

A comparison of views taken a century apart is rewarding because it underlines how many changes have taken place. Uplands Church, almost new in 1910 when this postcard view was sent, lacks its tower and steeple, not built until the early 1930s. Widespread house building has since taken place, trees have come and gone and business premises have been altered. In this case it has not proved possible to stand exactly where Stroud photographer Henry Comley did to take the earlier view.

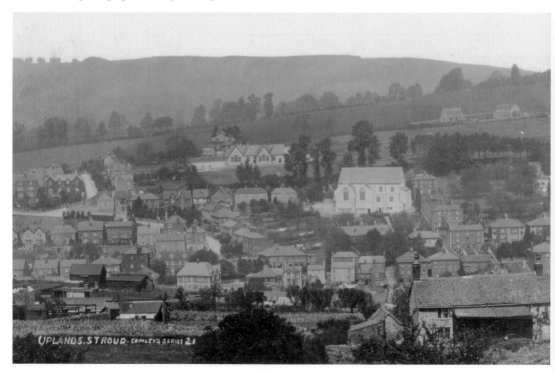

UPLANDS, STROUD. COMLEY'S SERIES 21

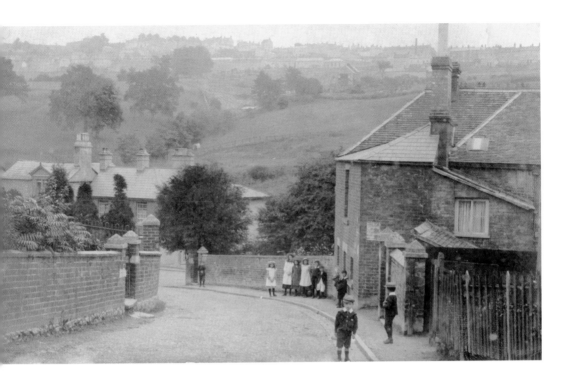

Looking down from Uplands Post Office

The house on the right has had its Victorian Welsh slates replaced by pantiles and a wall removed to provide car parking space. However, the most obvious difference between the two pictures is the replacement of the building in the middle distance by the recently-completed Newland Brook development. Note also the modern flats which now dominate the skyline.

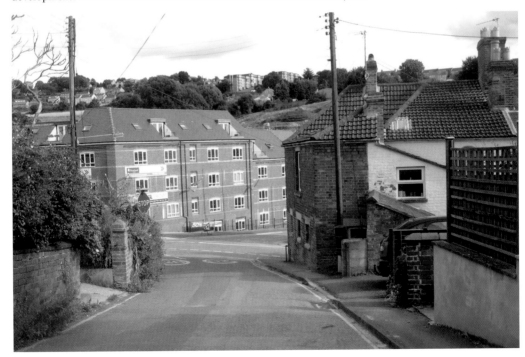

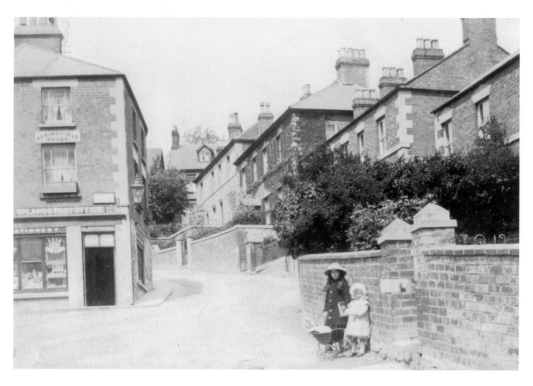

Uplands Post Office

In Edwardian days a Mr Jefferies was the Postmaster at Uplands and it was no doubt he who sold the card showing the two little girls with their pram. In the summer of 2008 Uplands Post Office, in common with others all over Britain, is fighting closure. Happily – and unusually – it won its battle to stay open.

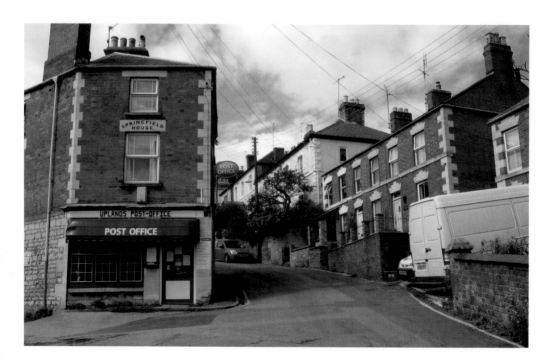

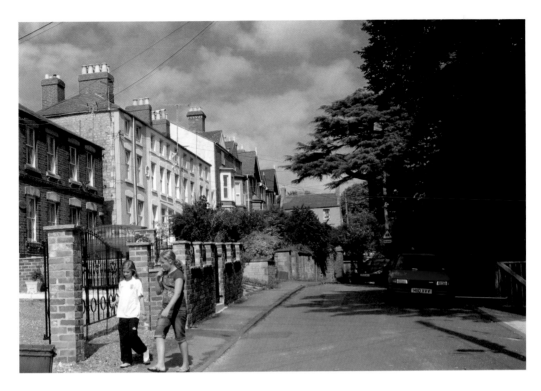

Lower Springfield Road, Uplands

In 1874 the author's maternal grandfather was born in one of the houses shown here. At that time they had only recently been built. The properties themselves have changed very little over a century except that the wall on the left has been pierced in places to allow vehicles to park off-road. The trees on the right – or their replacements – overhang in a similar manner in both photographs.

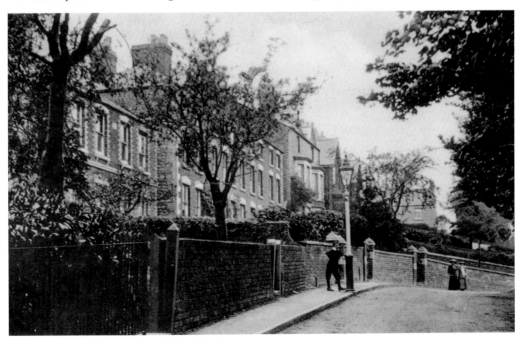

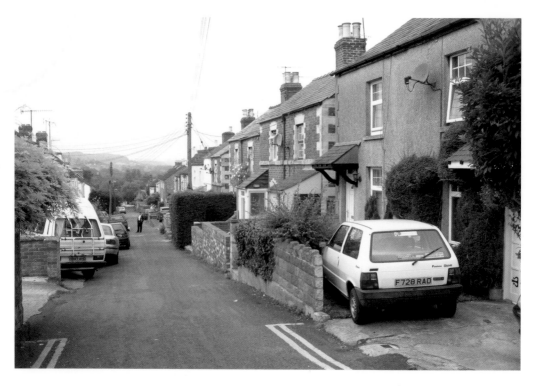

Middle Street, Uplands

Victorian railings were frequently removed during the last war for conversion into armaments. This may be the case here, or they may have disappeared simply in order to provide parking spaces. Since the earlier photograph was taken houses have also acquired overhead wires, satellite dishes and porches.

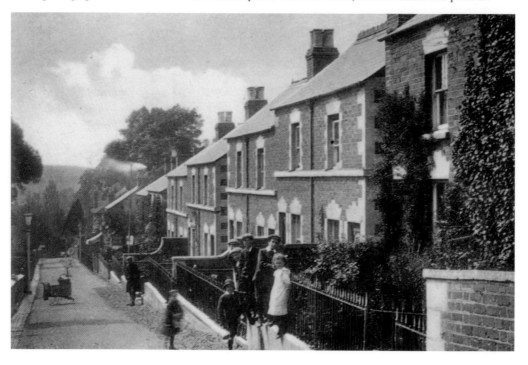

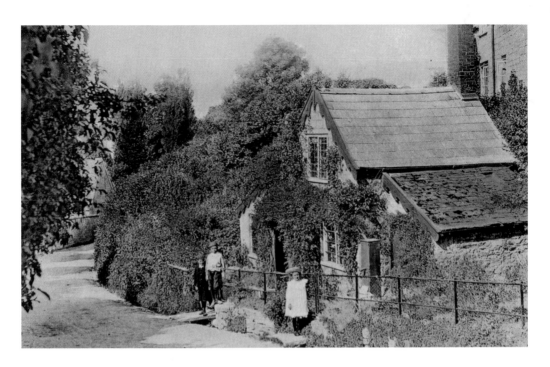

Folly Lane, Uplands

The cottage shown in the tinted Edwardian picture was taken down for road widening. The story goes that, some time before, a large hay wagon overturned and its load almost covered the building apart from the chimney! The gable just discernible in the distance on the left belongs to The Birches, run for many years as a private school by the Misses Brinkworth. The author's parents were invited to use The Birches lawn as a venue for their wedding reception in 1932. In retirement Miss Ethel Brinkworth, a fine musician, continued to give piano lessons, as many older Stroud residents may recall.

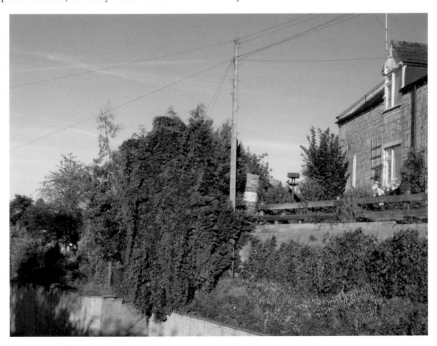

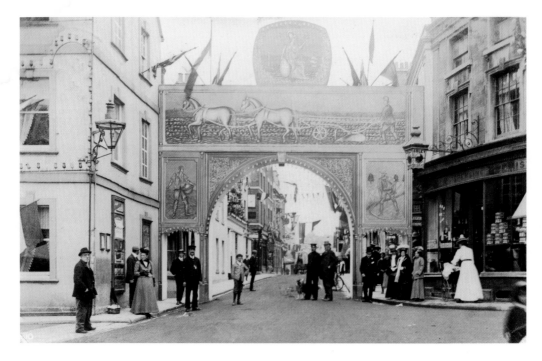

The arch erected across King Street to celebrate the visit of the County Agricultural Show in 1907.

Acknowledgements

P K Griffin, P S Harris, Mrs S Harrison, the late W J Lines, Museum in the Park, Mrs M Tuck, L F J Walrond, B Ward-Ellison and the collections of the late W J M Merrett and the late Mrs M Payne. Especial thanks also to my wife Sylvia.